THE CINCINNATI REDS
1950–1985

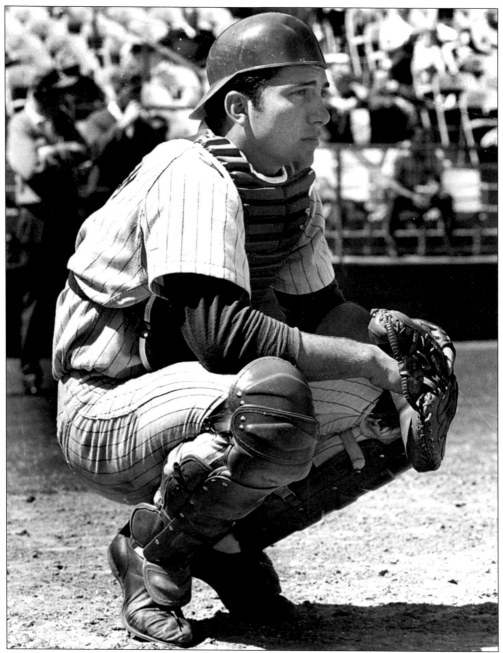

The best catcher of his generation, and one of the top backstops in baseball history, Johnny Bench was the backbone of the Big Red Machine. From his rookie days in 1967 to his retirement in 1983, Bench won two Most Valuable Player Awards, ten Gold Glove Awards, and was named to the All-Star team fourteen times. He revolutionized his position, holding his throwing hand behind his back and snaring the pitch with only his glove hand. Bench's footwork, speed, and accuracy made him a terror to base runners. In 1989, he was elected to the National Baseball Hall of Fame.

THE CINCINNATI REDS
1950–1985

Jack Klumpe and Kevin Grace

ARCADIA

Published by Arcadia Publishing
Charleston SC, Chicago IL, Portsmouth NH, San Francisco CA

Printed in Great Britain

Library of Congress Catalog Card Number: 2004108356

For all general information contact Arcadia Publishing at:
Telephone 843-853-2070
Fax 843-853-0044
E-mail sales@arcadiapublishing.com
For customer service and orders:
Toll-Free 1-888-313-2665
Visit us on the internet at http://www.arcadiapublishing.com

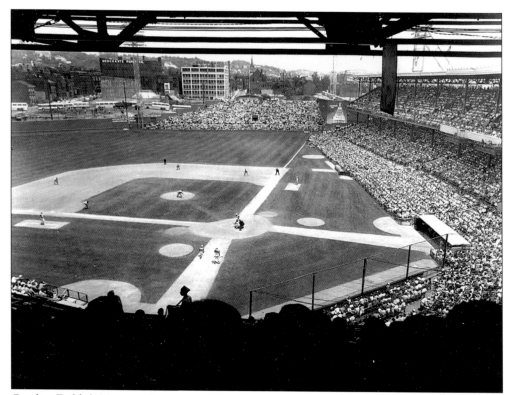

Crosley Field (1934–1970) stood on a site devoted to Reds games since 1884. Located at Findlay and Western Streets, Crosley was preceded by Redland Field (1912–1934, renamed when Powel Crosley purchased the team), Palace of the Fans (1902–1912), and League Park (1884–1902). Built at a cost of $400,000 by the local architectural firm of Hake & Hake, Crosley/Redland was host to World Series play in 1919, 1939, 1940, and 1961.

CONTENTS

A BOYHOOD
IN REDS COUNTRY

Many, many baseball seasons ago, when I was a boy in the 1960s, going to a Reds game was an adventure. Since I lived in a rural town north of Dayton, Ohio, I typically was able to go to only one game a year, two if our family had relatives visiting from Iowa and we wanted to make a day of it at the zoo and the ballpark. But usually it was just the single event, along with the other players in the Northmont Amateur Baseball League like Robbie Riber, Jackie Spangler, and Orville Wright, who, inadvertently on the part of his parents, had to share the name with the more famous Orville. Along with a score of others, they were variously my teammates and competitors, depending upon which team selected us every spring. We wore our "N" logo baseball caps because at that time it marked us as ballplayers. Yellow school buses brought us south down the Interstate 75 in late afternoon, and you knew when you approached Cincinnati because the smells began: acrid paper recycling in Lockland, sharp soap smells from Procter & Gamble in St. Bernard, and finally, Crosley Field in the West End.

Of course the Crosley smells were the best. Outside the park, Peanut Jim, as dubbed by the fans, clad in dusty black from his top hat to his shoes, blended with the rusty black of his cart where he roasted peanuts and sold them to the fans who knew they were infinitely better than any that could be bought inside. And once inside, through the turnstiles and past the grumpy ticket takers: the pungency of beer, cigars, hot dogs, and the dampened infield. The smells of the game are what I best remember.

But I also remember the faces of the Reds, never close enough to our group seats to see very well (and there were many bad seats at Crosley!) but in the packets of photographs you could buy at the souvenir stands. They were black-and-white shots in a white envelope with a crinkly cellophane window—Fred Hutchinson, Jim Maloney, Pete Rose, Jim O'Toole, Bob Purkey, John Edwards, Leo Cardenas, Frank Robinson, and on and on. They were more precious to me than baseball cards because they seemed more personal and immediate. It wasn't until several years ago that I discovered these pictures had been taken by Jack Klumpe.

I met Jack in 1984 when he was winding down his long career at *The Cincinnati Post*. He came into the archives at the University of Cincinnati bearing various items from his time at the newspaper, a very tall, very white-haired fellow who folded his height down into a chair and told me of his student days at UC. A friendship grew. Over the next few years, Jack would call

or come by from time to time, always with an anecdote about photographing sports, or about covering a politician or some noteworthy event in Cincinnati history. His life was rich and fascinating, being right in the middle of things as he was. And because we were fellow alumni, we often compared notes on the state of the university, and branching afield, the state of the national pastime since I teach a course on the social history of baseball. Jack said that one day he would gather many of these pictures together and present them to the university. This book contains a generous selection of his Cincinnati Reds photographs.

Jack Klumpe followed the Reds from spring training to Cincinnati, from Crosley Field to Riverfront Stadium (Peanut Jim also followed the Reds to Riverfront Stadium, and so did I). Jack witnessed some of the greatest players and events in franchise history, and saw better than most the beauty and power of the Big Red Machine. And nearly every day of every summer of his career, he shared his view with the fans. It was an uncommon and gracious view because Jack knew for the reader who may only get to one or two games a year, the newspaper photograph became part of the experience of loving a team.

Those games I attended as a boy are probably filled as much with the convoluted impressions of nostalgia as they are with historical facts: I definitely remembered the hunched stance of Frank Robinson so close to the plate, daring pitchers to hit him. Often they did. And often he knocked the ball for a home run. I believe I remember how big and mean pitcher Bob Gibson of the Cardinals was supposed to be, but I have just this wisp of memory of him finishing his warm-ups before a game and then walking along the first base line, tossing baseballs into the hands of enemy fans. However, I do know for sure that after the games, late at night, we climbed back on the buses for the drive home and in the dark I clutched those envelopes of photos. Well, Jack, I still have those photos. Thank you.

–Kevin Grace

REFLECTIONS ON
A CAREER

Imagine crouching fifteen feet from home plate during a Cincinnati Reds baseball game with a camera at eye level. Then a player like Ted Kluszewski slides toward home plate. At the climactic moment of the tag, the flash from the camera floods the action. And the players blinkingly accept my intrusion as all part of the game.

For those witnessing today's coverage of a baseball game by the media, this scenario from the late 1940s might seem a concocted story. Believe me, this is how over a quarter century of "covering" the Reds began for this photographer. At one time, one photographer from each of the Cincinnati newspapers, *The Cincinnati Post, The Cincinnati Enquirer,* and *The Cincinnati Times-Star* was allowed to be on the field throughout the game. The Reds were the last team to permit this Major League Baseball privilege to photographers because no off-field camera positions were provided by the club.

A September game in 1947 was the first game to be televised from the park using two cameras. One was behind home plate and the other near first base. Following Opening Day in 1948, and 31 other weekday games that year, it was readily apparent the public's reliance on viewing a still picture in the newspaper from yesterday's game was in for big changes. By Opening Day 1949, the Reds had built two camera positions exclusively for television. From the second deck near third base and the other from a location by first base were hung two platforms, termed "gondolas." But the press photographers still held doggedly to their questionable positions on the field.

The camera in vogue at the time was a *Speed Graphic*, usually with a 127 mm lens. The film was housed in a device called a "plate holder" with one sheet of film on each side of the holder. The holder was inserted into the back of the camera and a cover slide was pulled away so the film would be exposed to any image in front of the lens when the shutter was tripped. After making the picture, the slide was replaced into the holder so it could be removed from the camera. This process was reversed with the other side of the holder placing the other sheet of film ready for the next picture. For a night baseball game under the lights, a flash bulb was a necessity.

The exact date is lost in memory, but in the early 1950s an event ended the on-field presence of the photographers. It was on a warm summer night that I was covering a game along with Gene Smith, who represented the *Associated Press,* and who was affectionately known as "Smitty." It was much like all the other games where we stood on the top step of the Reds dugout waiting for the photo opportunity. When a runner reached first base, we sprang into

action and moved to a position in the coach's box. If the runner dove back to first, we fired our flash and a picture was made. If the runner reached second base, we would alter our position near home plate in the hope of getting a runner scoring.

On this particular night, some sort of altercation began at second base between a Reds player and the opponents' second baseman. We thought we had, the "run" of the field, and Smitty and I rushed to the fray to cover the event. The home plate umpire this night was the always seemingly jovial, yet all-businesslike Jocko Conlan. When we arrived with cameras at the ready, Conlan brushed aside his heavy exterior chest protector and ordered us away. At some point in the brief confusion around the "keystone" bag, Smitty overheard conversation to which he was not privy. What he heard on the field in the exchange among the umpires found its way into print the next day.

Conlon, on reading the newspaper account of the game, was furious and obviously ordered the Reds to rescind on-field privileges. In other cities, the press had been off the field for years and was making their pictures in the stands provided for them. Except for the new television positions, the Reds had no off-field locations for the still photographers. The only recourse was to move in with them. We did. But the abruptness of the decision to do so found us with no equipment to do the job.

The *AP* quickly provided Smitty with a camera called a "Big Bertha." He was to supply the *Times-Star* with its pictures from the game. The *Post*'s affiliation was with *United Press International*. UPI provided the newspaper with one of the monsters that had a lens with a 36-inch focal length. It made pictures on 5x7-inch cut film, and to protect the fans below, should it fall, it was chained to the TV platform. The camera was inefficient and troublesome to guide to the action while looking at an image reflected on a ground glass that was shielded by a hood. The camera was too heavy and unwieldy to be carried from the park so the Reds built lockers in the gondola to store the monster.

In the years to follow there would be many changes in the equipment the press photographer used to chronicle the events on and off the playing field. In Cincinnati, I pioneered in all of these changes. The "*4x5 Speed Graphic*," the workhorse of early photojournalism, was replaced by the *Rolleiflex* twin lens reflex camera using roll film in a $2\frac{1}{4}$ x $2\frac{1}{4}$-inch format. A Japanese camera that had found instant favor with those covering the Korean War introduced photojournalists worldwide to the 35 mm *Nikon* camera. The downsizing from the bulky plate holder camera to the miniature camera opened unbelievable new techniques to the photographer.

The West German company making the 35 mm *Leica* devised a system they called a "Leicaflex" in hopes of competing with the single lens reflex (SLR) *Nikon*. For one season we tried the camera, using a squeeze-focus 400 mm *Novaflex* lens from our camera position of many years at Crosley Field by the third base line. Its disadvantage was that it took only one frame of film at a time. When the shutter was tripped, the viewfinder went blank just like the old *Graflex* camera of the 1920s.

With the 35 mm format making rapid inroads in professional photography, another West German development made its appearance, a camera called *Robot*. Its advantage was that it would take three photos per second using a spring windup motor. A new era was dawning and action photography would never be the same. The disadvantage of the camera was its high cost and its lack of adaptability to telephoto lenses. In its frugality, *UPI* was experimenting with a cheaper East German camera called the *Hexacon*. It too would take as many as three pictures per second, and could be adapted to several longer lenses needed for covering action at second base from 150 feet away. For several years the camera performed well, even though it had a habit of stripping the sprocket holes in the 35 mm film.

In about the last fifteen years that I was Chief Photographer at *The Cincinnati Post*, the 35 mm *Nikon* became the mainstay of my sports photography. Its battery-powered motor and long telephoto lenses allowed me to make pictures that never could have been envisioned in those earlier years while scampering from first, to home, to third base to get that baseball action picture.

Many of the pictures contained in this book that were made over that span of 30-plus years from 1950 to 1985, now only in recollection, saw many changes in equipment. What was pioneered in those years brought us to the automatic focusing and aperture setting digital cameras today. One fact, however, remains: what sets one photographer apart from the rest, regardless of the camera, is that knowledge of when to trip the shutter.

On September 11, 1985 at Riverfront Stadium, I made my last professional picture using my *Nikon* camera with an 800 mm lens and a tele-extender to create a 1600 mm lens. The film was Fujichrome set for an exposure of about f/8 at $1/125$ of a second, "pushed" to 1600 ASA in development. The image, over 400 feet away from a camera position in the centerfield stands, was that of Pete Rose making his 4192 hit to break Ty Cobb's record. I had retired from the newspaper the previous month and *United Press International* had prevailed upon me to assist that night. That click of the shutter ended my 43-year career in journalism.

–Jack Klumpe

ONE
The 1950s

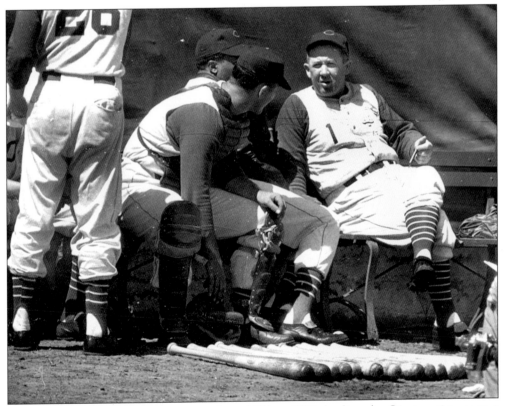

Birdie Tebbetts was the Reds manager from 1954 to 1958, leading the Cincinnati team to a record of 372 wins and 357 losses over that stretch. He ranks seventh in Reds managers' wins, and his tenure witnessed the explosion of a new era of sluggers on the squad.

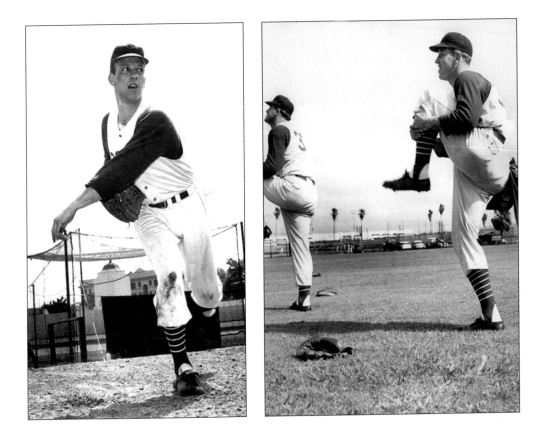

Joe Nuxhall, one of the most popular figures in Cincinnati baseball history, made his debut with the Reds during World War II at the age of 15. As many Major League rosters were depleted by players enlisted in the Armed Forces or taking jobs in war-related industries like shipbuilding and munitions, it gave the opportunity to play big league baseball to several individuals who may not have had a chance otherwise. Outfielder Pete Gray with the St. Louis Browns, for instance, was able to make the team despite missing his right arm. Nuxhall, a schoolboy pitcher from Hamilton, Ohio, pitched two-thirds of an inning for the Reds in 1944 against the Cardinals and was shelled, sending him back home. Eight years later in 1952, Nuxhall would be back with the Reds, tossing for them until 1960 and then again from 1962 to 1966. His best year was in 1955 when he went 17-12 and was named to the All-Star team.

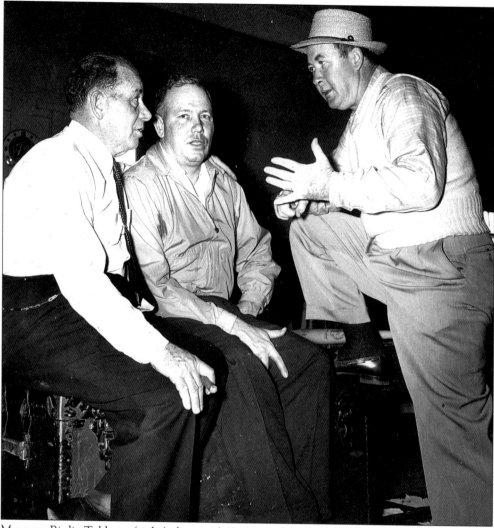

Manager Birdie Tebbetts (right) chats with Reds coaches Jimmy Dykes (left) and Tom Ferrick (center) in the mid-1950s. During their own playing days, Dykes an outstanding was second baseman, Ferrick was a journeyman pitcher, and Tebbetts was a catcher with the Tigers, the Red Sox, and the Indians. As a Tiger backstop in 1940, Tebbetts played against the Reds in the World Series, batting 0-for-11 in four games. When Tebbetts resigned as manager during the '58 season, Dykes succeeded him and finished out the year.

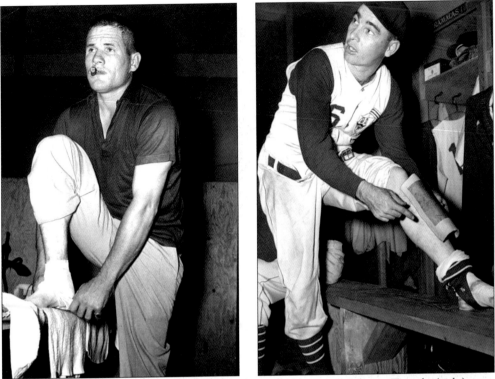

Utility infielder Rocky Bridges (*left*) and steady second baseman Johnny Temple (*right*) were known as much for their tobacco use as their sterling play. A 1953 *Cincinnati Enquirer* article discussed "What Happened to Hearty Tobacco Chewers?" like Bridges and Temple. At the time, it seemed that baseball was giving way to more cigarette smokers than chewers, due in part—according to the article—to the influence of players' wives who objected to the mess of chewing tobacco. Nevertheless, the duo still favored a good chaw while on the diamond. In the Temple photo, he is shown strapping on a shin guard to protect himself from the spikes of sliding runners.

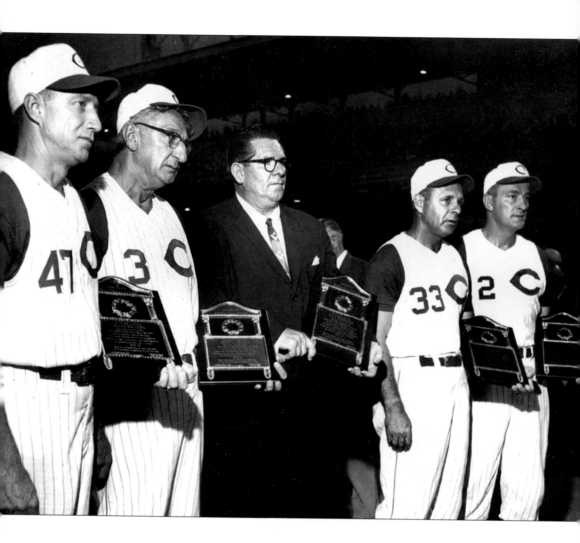

In 1958, the Cincinnati Reds inaugurated their own Hall of Fame, honoring five outstanding players in team history. Pictured from left to right in the group photo are pitcher Bucky Walters, catcher Ernie Lombardi, pitcher Paul Derringer, pitcher Johnny Vander Meer, and first baseman Frank McCormick. Derringer, holder of four 20-win seasons with the Reds, including 25-7 for the 1939 pennant winners and 20-12 for the '40 World Champions, shows off his pitching form. An emotional Lombardi, winner of the 1938 National League Most Valuable Player award with a .342 average, holds his Hall of Fame plaque aloft.

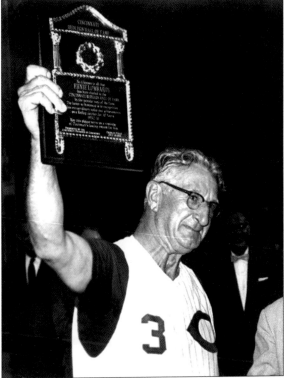

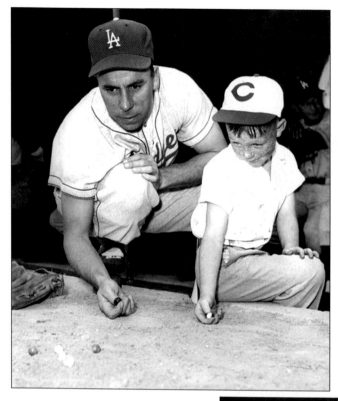

Los Angeles Dodgers shortstop Pee Wee Reese, a Cincinnati favorite because he hailed from Louisville just 100 miles down the Ohio River, demonstrates to a young fan how he got his nickname. Reese was a childhood marbles champ in Louisville, and made his debut with the Brooklyn Dodgers in 1940. He spent his entire career with the team, ending his playing career after the Dodgers' move to Los Angeles in 1958. For a brief time, (1969–70), Reese was the television color guy for the Reds.

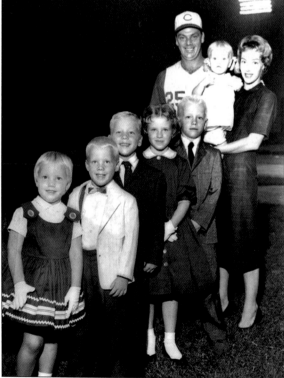

Outfielder Gus Bell poses for the camera with his wife and six children. Bell was one of the great power hitters the Reds had in the 1950s. Dealt from the Pirates after the 1952 season, Bell played for Cincinnati from 1953 through the pennant-winning year of 1961, clubbing 160 home runs. His son Buddy, fifth in the line of kids from the bottom, also had a sterling Major League career, and was one of the best third basemen of his generation. Buddy played for the Reds himself from 1985 to 1988.

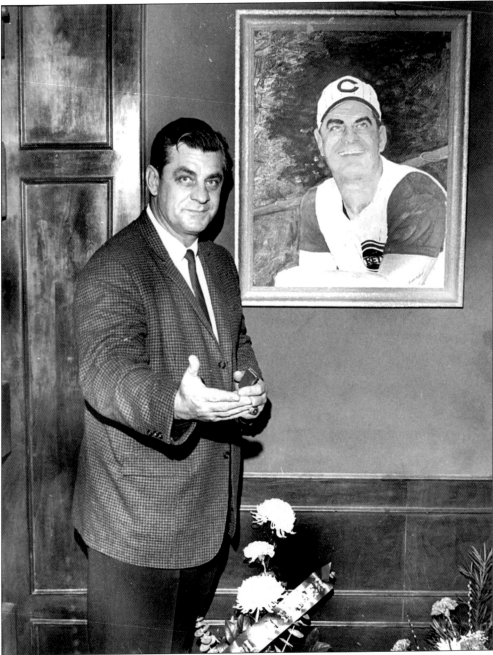

"Big Klu," one of the strongest men in baseball during the 1950s, poses here in his popular Cincinnati restaurant. Ted Kluszewski came up to the majors with the Reds in 1947, and played first base for Cincinnati for eleven seasons. His best year was 1954 when he smacked 49 home runs and knocked in 141 runs. Overall, Klu hit 279 homers in a 15-year career in the Major Leagues. He served as a coach for the Reds from 1970 to 1978, and a few months after his death in 1988, Big Klu's uniform number was retired in a ceremony on July 18.

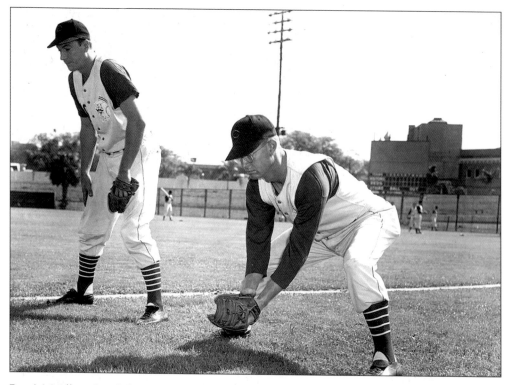

Roy McMillan played shortstop for the Reds from 1951 until his trade to the Milwaukee Braves after the 1960 season. The bespectacled McMillan was a great glove man up the middle, and formed a wonderful double-play tandem with Johnny Temple. The top photo shows him working out during spring training, and the bottom photo is of a Fan Appreciation Night at Crosley Field when McMillan joined other Reds players in handing out gifts to lucky ticket-holders.

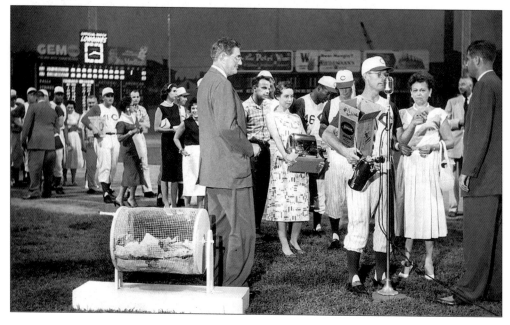

William Ellsworth Hoy, called "Dummy" during his career from 1888 to 1902 because he was a deaf-mute, played for Cincinnati from 1894 to 1897 and again in 1902. Shown here receiving an honor from the Reds, Hoy is accompanied by his son Carson (right), a noted athlete during his college days at the University of Cincinnati who became a coach at the Ohio Mechanics Institute before pursuing a career in the law.

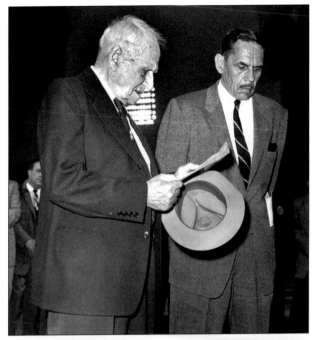

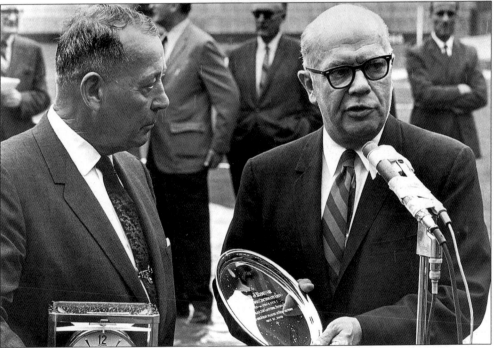

In another Crosley Field ceremony in the 1960s for a former Red, baseball historian Lee Allen (right) presents an award to legendary centerfielder and Hall of Famer Edd Roush. Roush, one of the more cantankerous players the Reds have ever had (he saw little need for spring training since he always stayed in shape, and he was never reluctant to return what he considered a contract paying him below his worth), played for the team from 1916 to 1926, and again in 1931. He had a lifetime batting average of .323 and was elected to the National Baseball Hall of Fame in 1962.

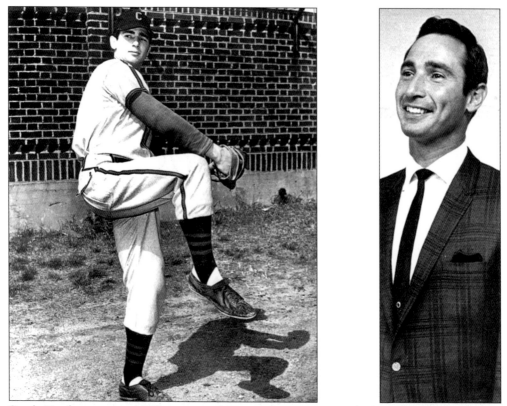

Sandy Koufax came to the University of Cincinnati in 1953 on a basketball scholarship, with the intention of studying architecture. His blazing speed on the pitcher's mound (*left*) was already well known however, and when he expanded his athletic horizons by pitching for the Bearcats in the spring of 1954, scouts took a serious look at him. The Reds gave him only a cursory look, though, and he signed with the Brooklyn Dodgers. On his way to a Hall of Fame career with the Dodgers, Koufax regularly made it back to Cincinnati to battle the Reds, and on one occasion, stopped at UC to battle other Bearcat alumni in a quiz show (*right*).

TWO

The 1960s

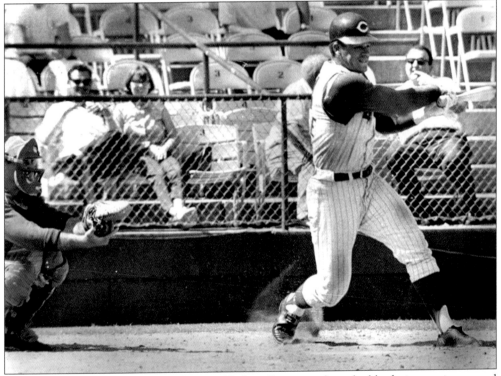

During a spring training on March 6, 1967, Pete Rose smacks a double during an intersquad game as catcher Don Pavletich waits for a pitch that never made it to his mitt. Rose came to the majors in 1963 and would become a constant image of hard-nosed Reds baseball.

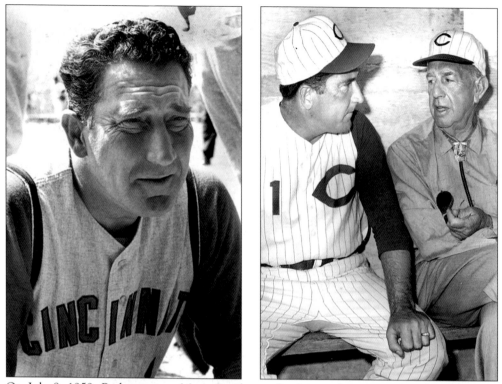

On July 8, 1959, Reds manager Mayo Smith was fired in mid-season and replaced by Fred Hutchinson (*left*). Hutch, a former pitcher for the Tigers from 1939 to 1953, appeared in the 1940 World Series against the Reds, pitching one inning, giving up a hit, a base on balls, and a run. He finished his mound career with a record of 95-71. By all accounts, Hutch was a man of considerable temper, but he was well respected by his players and beloved by the fans. Hutchinson finished the '59 campaign with a 39-35 record, and set about building the Reds into a power for the 1960s. In the photo on the right, he talks with Reds owner Powel Crosley at spring training in 1960.

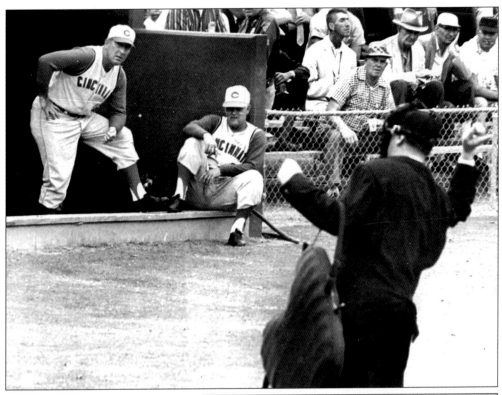

The volcano that was Hutch's temper was usually directed at water coolers, walls, and bat racks, but umpires fell in for a fair share of its expression as well. In the top picture, Hutchinson argues a call during a March 17, 1964 spring training game. American League umpire Al Salerni, working behind the plate that day, then gives him the heave-ho. But with a point or two still to make, Hutch comes out on the field to further express his opinion.

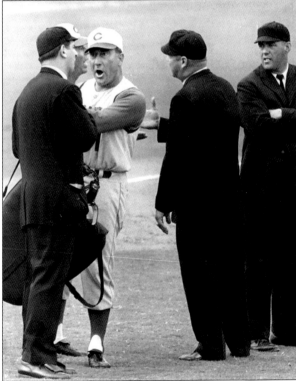

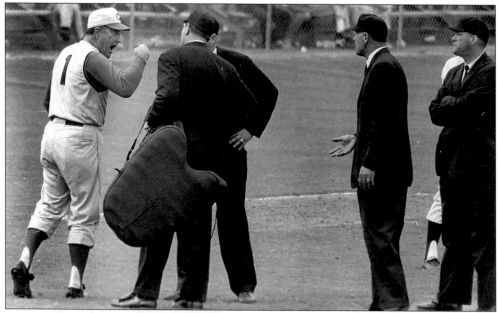

In that same game, once he had the field Hutch continued to gently make his point that Salerni may possibly have erred in his decision. But no, the umpires averred, the decision must stand, and Hutch must indeed leave the game.

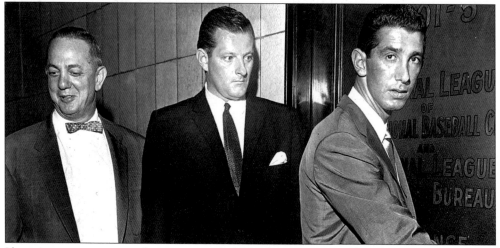

If umpires were a source of vexation to Fred Hutchinson, some of his players were no less so. On December 15, 1959, the Reds obtained second baseman Billy Martin in a trade with the Cleveland Indians, sending Johnny Temple to Cleveland for Martin, first baseman Gordy Coleman, and pitcher Cal McLish. Martin had already worn out his welcome with the Yankees, the A's, and the Tigers before landing with the Indians. In short order, he also wore out his welcome with the Reds. On August 4, 1960, Martin punched Cubs pitcher Jim Brewer, fracturing the orbit bone around Brewer's right eye. This photo is of Martin going into a meeting with National League president Warren Giles, who fined and suspended him. Brewer sued him, and won an out-of-court settlement. That December the Reds sent Martin to the Braves. Later, his managerial career was just as stormy, alternating between brilliant stints as a skipper and firings because of his temper.

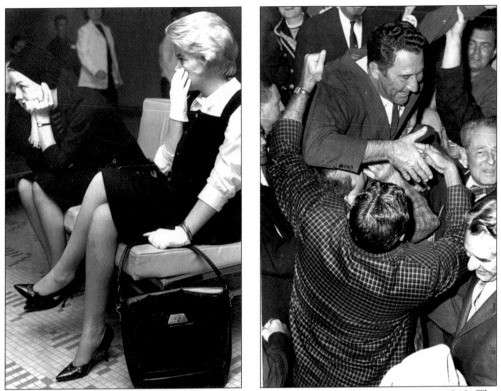

In 1961, Fred Hutchinson led the Reds to their first National League pennant since 1940. The team battled the Dodgers for most of the season, and in the top photo, the wives of Don Blasingame (*left*) and Ken Hunt (*right*) listen intently to the radio on September 26 to see if Cincinnati could hold off the pennant rush of Los Angeles. The Reds won the flag when the Pirates beat the Dodgers 8-0 and the Reds topped the Cubs 6-3. In the downtown celebration that followed after the team came back from Wrigley Field, former Yankee pitching great and Reds broadcaster Waite Hoyt raises his fist in triumph as Hutchinson is raised on the shoulders of the fans.

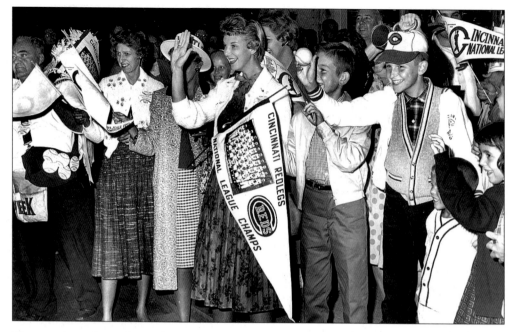

The top photo shows fans welcoming the team at Lunken Airport upon their arrival home that afternoon before the news arrived that the Pirates had defeated the Dodgers. More than 30,000 people crowded on Fountain Square downtown. Merrymakers poured soap into the fountain to make bubbles as the team came from the airport on a bus. The sign refers to what one fan hoped Cincinnati would do to Mickey Mantle, Roger Maris, and the rest of the Yankees. In 1961, in a season that saw Powel Crosley die the previous March, the Reds finished at 93-61. Frank Robinson won the N.L. MVP award with 37 homers and 124 runs batted in. The Reds also drew almost 1.2 million fans. Alas, the figurative soap bubbles burst in the World Series when the Yanks won four games to one.

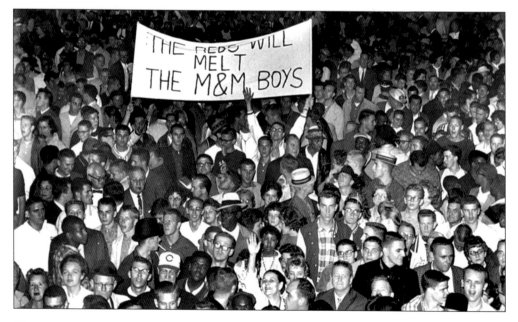

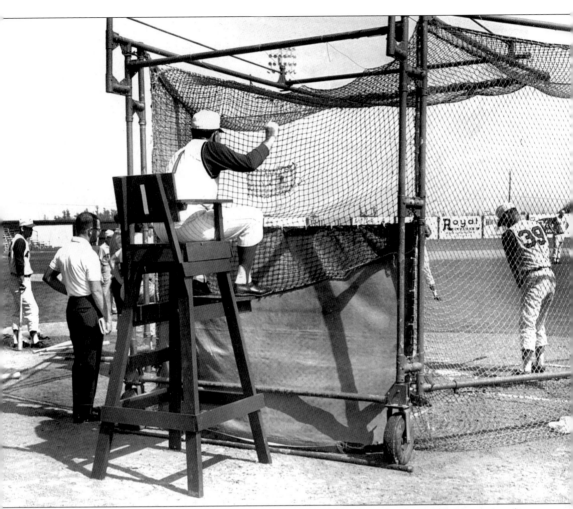

In 1962, the Reds faded to third place, followed by a fifth place finish in '63. However, the team's falling short of expectations was nothing compared to the devastating news in January 1964 when Hutchinson revealed that he had cancer. He had radiation treatment in Seattle, and made it to spring training, where a special chair was constructed behind home plate so he could observe batting practice and intersquad games. In an ironic turnaround, Hutch also used his perch to act as umpire, calling a strike on pitcher Don Secrist.

On August 12, 1964, Fred Hutchinson made his last appearance on a ballfield. The man whom Gordy Coleman had called a "massive bear of a man" in both character and appearance was wracked by cancer. There to be honored by the Cincinnati fans who loved him, Hutch addressed the crowd as the team stood behind him and Reds president Bill DeWitt broke down in tears. The next day, Hutchinson announced he was taking a leave of absence to continue battling his disease, and coach Dick Sisler was named the interim manager. But Hutch never came back. On November 12, he died. The bottom photo shows the Reds and Kansas City A's bowing their heads during a moment of silence for Hutch's memory in spring training, 1966. Manager Don Heffner (left), succeeded Sisler the previous October. Beside him is A's manager Alvin Dark.

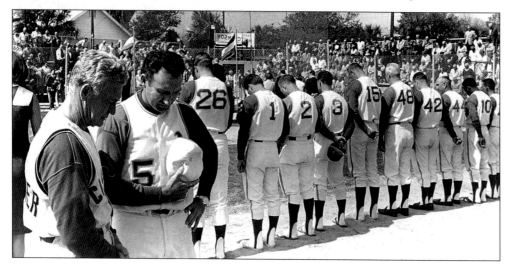

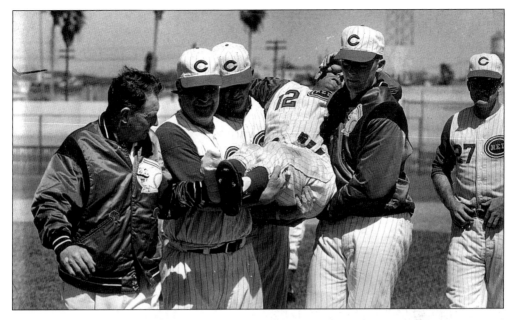

Third baseman Gene Freese came to the Reds on December 15, 1960 when the team swapped Juan Pizarro and Cal McLish to the White Sox for him. Pizarro had just been acquired from the Braves, along with Joey Jay, in exchange for Roy McMillan. Freese played for the Reds from 1961 to 1963 before being traded to the Pirates. His bat was helpful—26 home runs and 87 runs batted in for the pennant year of 1961—but his defense was weak. These photos were taken during spring training in 1962. On March 5, Freese broke his ankle in a botched slide into second base. His teammates carry him from the field, before getting him on a cot. Freese has a cigarette while his ankle is iced. After the accident, Freese finished his career as a utility player.

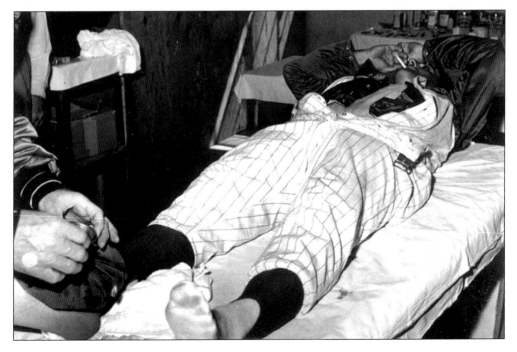

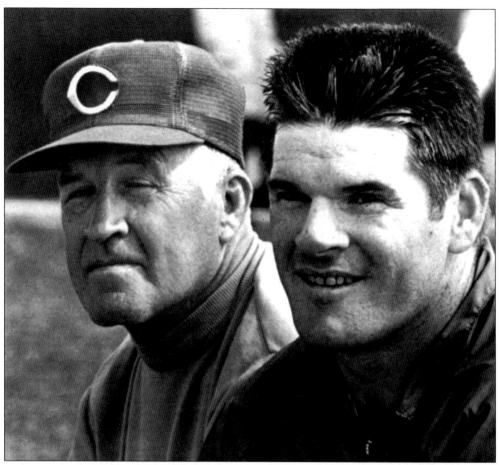

Pete Rose poses with his father Harry before Opening Day at Crosley Field on April 8, 1963. In his first at-bat, Rose drew a walk against Earl Francis of the Pirates, and ran to first base—a habit he would turn into the nickname "Charlie Hustle." The Reds beat the Pirates 5-2. Rose's first major league hit came five days later on the 13th when he smacked a triple off Pirate pitcher Bob Friend.

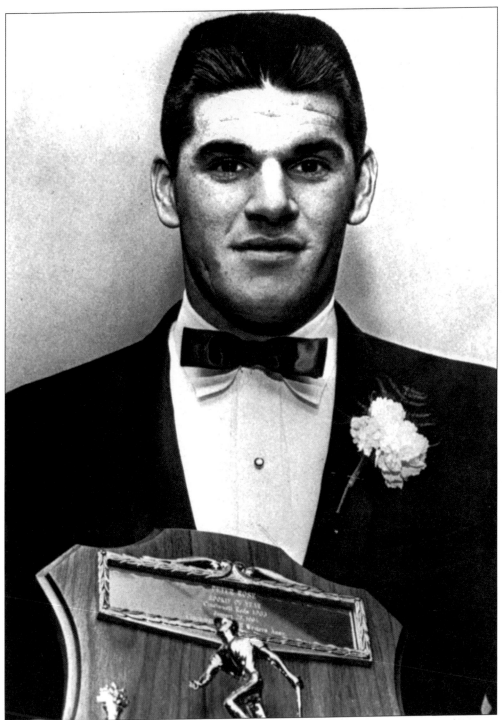

At a banquet on January 23, 1964, Rose accepted the award for the 1963 National League Rookie of the Year. As the starting second baseman for the Reds that season, taking the position from incumbent Don Blasingame, Rose batted .273 with 170 hits and led the team with 101 runs scored.

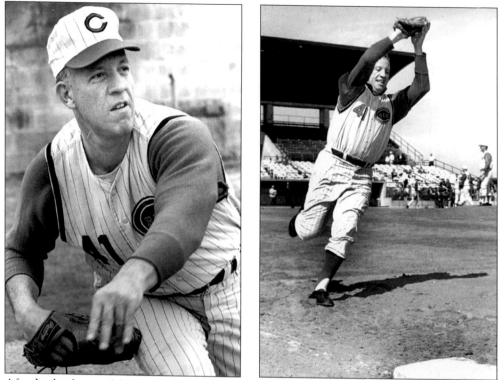

After his big league debut in '44 at the age of fifteen, Joe Nuxhall continued to develop his craft and made it back to the majors for good in 1952. During the 1950s with the Reds, he had some considerable success, especially in '54 when he went 12-5, and the following year when he posted a 17-12 record. He was dependable on the mound, but in 1960 his numbers began to drop off. Nuxhall was sent to the Kansas City A's, who subsequently lost him to the expansion Los Angeles Angels. The Angels dealt him back to the Reds early in the 1962 season, and he responded by going 5-0 the rest of the year. The next year, Nuxhall won 15 games against 8 losses. Over a 16-year career, he won 135 games. Nuxhall was also one of the better fielding pitchers in the National League and is shown in the bottom photo reaching high for the throw as he covered first base.

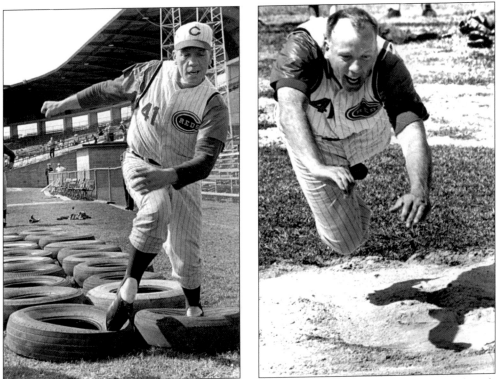

As these spring training pictures show, Joe Nuxhall worked hard to stay in condition, though he was a bit unorthodox in his run through the tires. In addition to his fine fielding, Nuxhall knew how to run the bases and was no slouch at the plate either. Nuxhall hit 15 home runs in his career—pretty substantial for a pitcher. The bottom photo shows Nuxhall yelling "Here comes Frankie Robinson" as he hit the sliding pit during a drill.

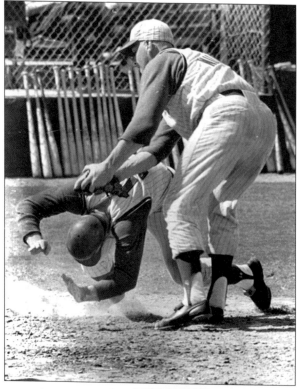

In a spring training intersquad game in 1967, Pete Rose is tagged out between third and home when he strayed too far off the base. Batter Deron Johnson had hit the ball to third base, but Len Boehmer, the third baseman, ran Rose toward home and then tossed the ball to pitcher Joe Nuxhall, who then tagged Rose out.

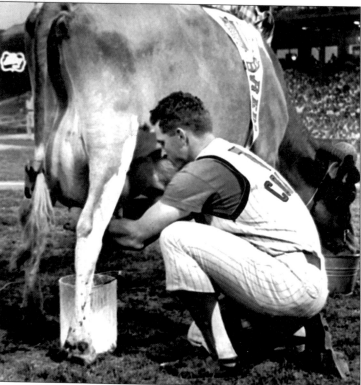

The Reds "marketing circle" of fans has always included many rural parts of Ohio, West Virginia, Kentucky, and Indiana, and for many years the team held a Farmer's Night every summer. The promotion traditionally included a pre-game cow-milking contest, and in this 1965 shot, catcher Jim Coker earnestly tried to get the cow to fill the bucket.

36

One of the most popular events every year at the ballpark was the annual fathers-kids baseball game, first staged on August 25, 1962. The fans loved seeing the players with their families, and many of the children took the game seriously—after all, they had a streak of undefeated games they had to extend every season. In the top photo, the junior Reds wait for the game to start, and in the bottom picture, Frank Robinson provides a little help to the runner in crossing the plate before the tag.

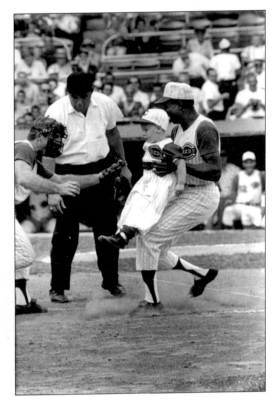

Mr. Red leads a dance team through its paces before a game at Crosley Field. The mascot had several looks over the years, including 1969 when images of him included a handlebar moustache to celebrate the Reds' centennial. However, he was the only Red with facial hair at the time.

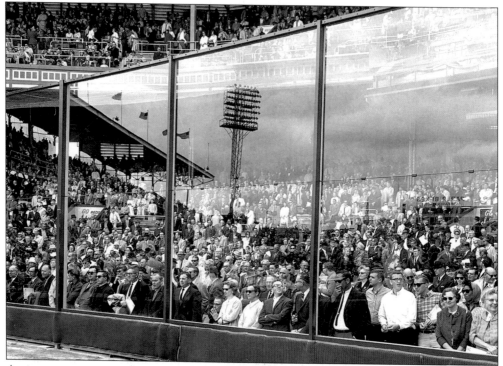

A view not seen very often in Crosley Field photos is this one of the folks behind home plate enjoying their own view of the game. Crosley had a glass backstop unique in the majors at the time, and even though the fans were adequately protected, they all flinched when a foul ball came crashing back.

After arriving home in Cincinnati after clinching the National League pennant in '61, jubilant teammates Vada Pinson and Frank Robinson broke into song for the welcoming fans.

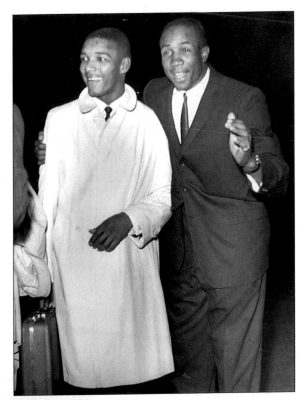

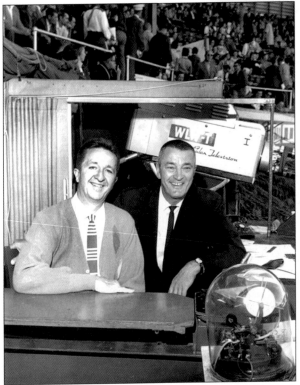

Fans in Reds country heard the duo of Ed Kennedy and former Reds player Frank McCormick when they watched the team on television during the 1960s. A charter member of the Reds Hall of Fame, McCormick played first base for the team in 1934, and from 1937 to 1945. Kennedy did the television play-by-play from 1961 to 1970, and McCormick was on the air from 1958 to 1968.

Reds players sample the local Florida strawberries during a spring training break in the 1960s, seemingly undecided whether they were ripe or not.

Tampa Little League players shake the hands of Reds players before a training game in 1966. Manager Don Heffner is at the far right.

In a '66 game against the Philadelphia Phillies, this photo shows shortstop Chico Ruiz leaping above Phillie Richie Allen for a throw to first. Bill White had lined a hard grounder to the right of Reds first baseman Tony Perez, who scooped up the ball and threw it to Ruiz to force Allen. However, on the return relay from Ruiz for the double play, the throw went over Perez's head, and White wound up on second base.

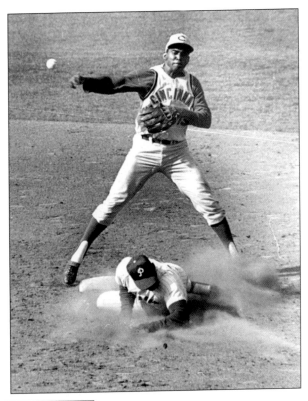

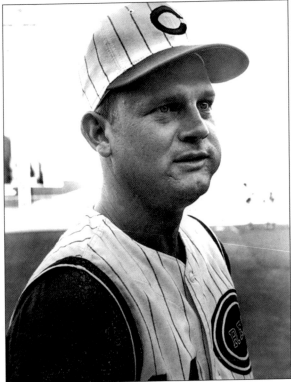

Hometown favorite Don Zimmer, who grew up in the neighborhood of Western Hills, came to the Reds in a trade from the New York Mets early in the 1962 season. Zimmer came up to the big leagues in 1954 with the Brooklyn Dodgers, but over the next several years suffered a series of injuries, including a devastating beaning. From the Dodgers, Zim went to the Cubs in 1960, and then to the Mets. He only stayed with the Reds for 63 games, and finished his playing career in 1964 with the Washington Senators. One of the great characters of the game, Don Zimmer became a coach and manager, and as of 2004 was still active in the Major Leagues as an advisor for the Tampa Bay Devil Rays—more than a half-century in the game. In this photo, he is shown in a familiar look: a wad of chewing tobacco in his cheek—Zimmer is also one of the great chewers in baseball history.

41

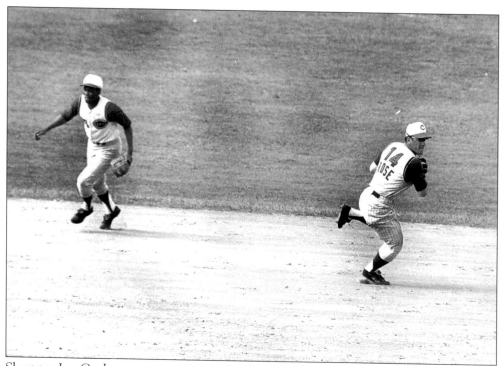

Shortstop Leo Cardenas scoops up a grounder, flips it to second baseman Pete Rose to force the runner, as Rose readies to throw on to first.

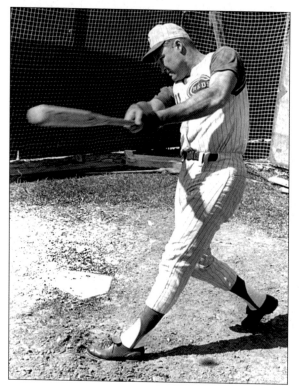

In 1964, slugger Deron Johnson came to the Reds. For four seasons, he mainly played first base and third base, and his bat provided the team with some clout. In his seasons with the Reds, Johnson averaged over 22 homers and almost 86 runs batted in each year.

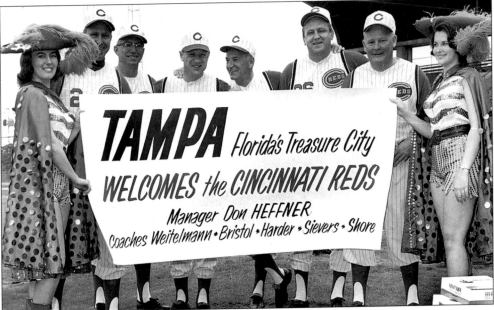

Tampa Bay always welcomed the Reds for spring training in the 1960s with a little ceremony. In this 1966 photo, the manager and coaching staff are honored. Pictured from left to right are Paula Gibson, Roy Sievers, Mel Harder, Dave Bristol, manager Don Heffner, Ray Shore, Whitey Wietelman, and Linda Dunn.

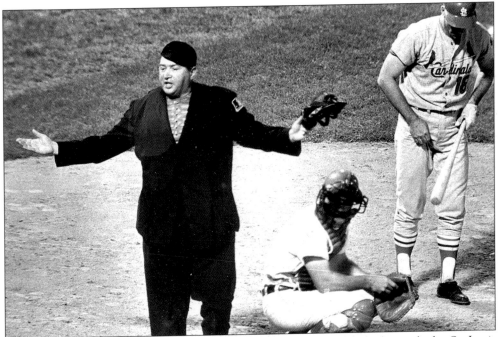

From a game in June of 1969, home plate umpire Stan Landis has had it with the St. Louis Cardinal bench. Throughout the game, the Cardinal pitcher had argued with the umpire about several calls, and continued the dispute when St. Louis was at bat. Johnny Bench is the catcher, and Cardinals third baseman Mike Shannon is the batter.

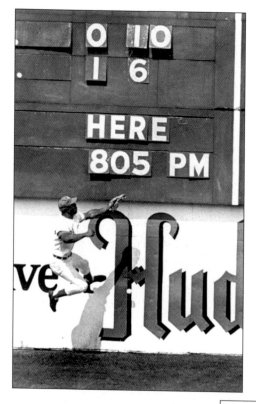

Alex Johnson played for the Reds from 1968 to 1969, coming from the St. Louis Cardinals in exchange for Dick Simpson. In this photo, Johnson tries to play a ball hit by Joe Torre off the Hudepohl Beer sign below the scoreboard.

Trying to get in shape for the '68 season, pitcher George Culver (left) and outfielder Jim Beauchamp (right) have a try at skipping rope during spring training.

44

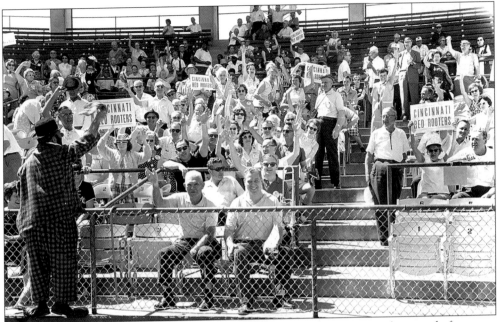

The Red Rooters, down in Tampa to get rid of the Cincinnati winter and get ready for a new season, are greeted in the stands by a visiting clown. Cincinnatian Dave Kettler, in the front row, waves to the camera.

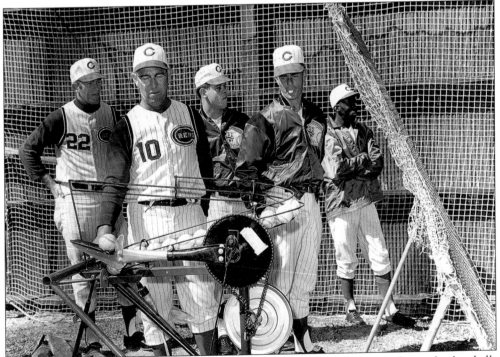

Coach Vern Benson feeds balls into a new pitching machine that can throw the baseballs overhand in order to simulate the motion of a pitcher. Standing by to see if they can pick up some tips are, from left to right, pitchers Mel Queen, Billy McCool, Sammy Ellis, and Ivy Washington.

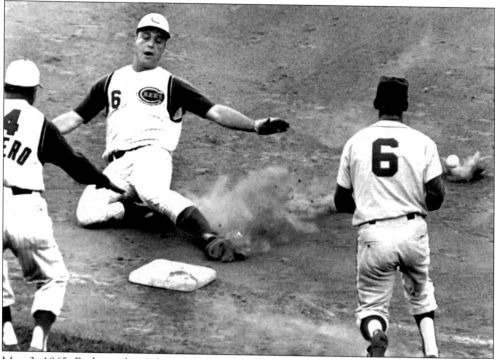

May 3, 1965, Reds catcher Johnny Edwards triples in the sixth inning when he pinch hit for pitcher Roger Craig. Coach Reggie Otero signals for Edwards to slide.

And for a last shot of the great Fred Hutchinson, in the May 23, 1964 game against the Chicago Cubs, Johnny Edwards argues in vain with umpire Ed Vargo. The Reds catcher maintained that Cubs pitcher Bob Buhl, who was batting, interfered with him when Buhl tried to execute a squeeze bunt that brought runner Andre Rodgers home from third. Hutchinson strides out to give his opinion as well.

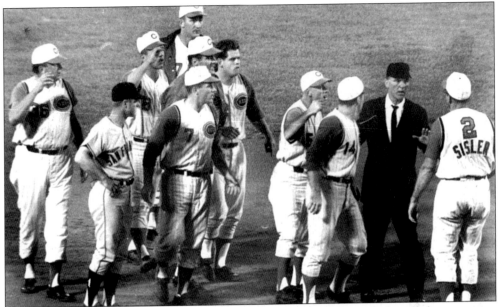

Crosley Field had a yellow line painted across the outfield wall to mark the wooden extension of the fence in center field. According to the ground rules, a ball hit above the yellow line was a home run. In a Reds-Giants game in 1965, Pete Rose smacked a deep drive to the outfield, and thought he had a homer. Umpire Shag Crawford thought otherwise, and his ruling brought out the Reds in force from their bullpen. Giant Dick Schofield watches the argument that included, from left to right, coach Ray Shore, Don Pavletich, Jim Coker, Roger Craig, Joey Jay, Billy McCool, and coach Frank Oceak. Rose (#14) and manager Dick Sisler argue in vain.

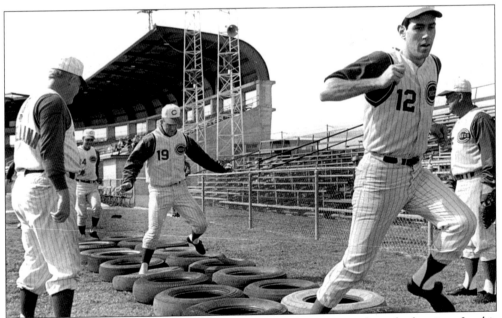

Spring training usually included agility conditioning by running through the tires. In this image, coach Whitey Wietelmann watches Tony Perez, Tommy Helms, and Art Shamsky plunge through the tires. Infielder Don Zimmer (with glove) watches from the side.

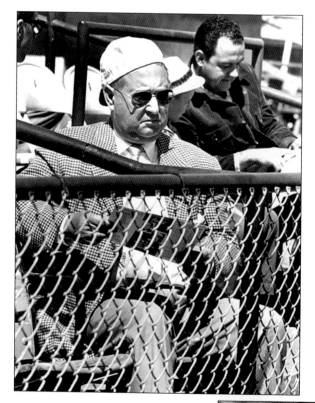

When Reds owner Powel Crosley died in 1961, the team's general manager, Bill DeWitt bought the club the following year. Though he was close to Hutchinson, and had some success with the team, the Reds never reached the levels of expectation, and DeWitt was roundly criticized when he dealt Frank Robinson to the Baltimore Orioles at the end of the 1965 season. The Reds had also been wrangling with the city of Cincinnati since the late 1950s on a new ballpark for the team, and DeWitt became frustrated with the lack of movement on the idea in the mid-'60s. In 1966, DeWitt sold the team to a group put together by publisher Francis Dale.

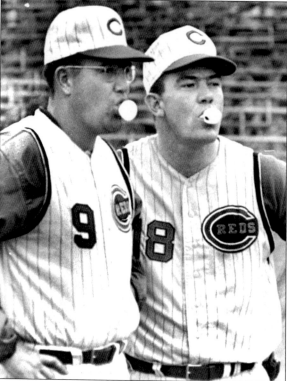

Minor league catcher Jim Saul and Reds first baseman Gordy Coleman blow gum bubbles during spring training as they wait their turn for infield drills.

Gordy Coleman came over to the Reds from Cleveland in the same 1959 trade that sent Johnny Temple to the Indians for Cal McLish and the volatile Billy Martin. Coleman played eight years for the Reds, anchoring first base. His best years were 1961 and 1962 when he clouted 54 homers and batted in 173 runs. After his playing days were over, Coleman worked in the Reds front office in community affairs, and he joined the Reds television broadcasts from 1990 to 1993.

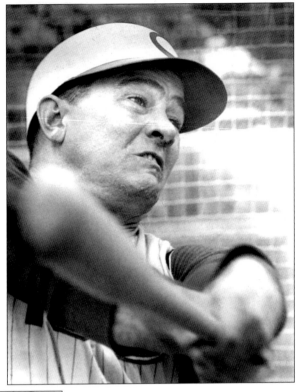

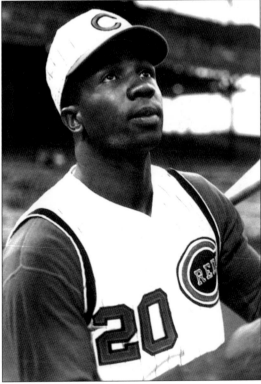

Frank Robinson arrived at Crosley Field in 1956, and became the leader of the Reds until 1966. One of the superlative players of all time, Robinson was a great fielder, a splendid base runner, and a fearless batter. His stooped stance at the plate was a memorable sight, as he whipped the bat around for homer after homer. In '56, he won the National League Rookie of the Year award, and the league's Most Valuable Player award in 1961.

49

Robinson did not always have a happy time during his years in Cincinnati. The fans and the media often got on him, particularly after an incident on February 8, 1961 when he was arrested in a local restaurant on a concealed weapons charge. However, after paying his fine and getting on with his career in the pennant-winning '61 campaign, no one could doubt what Robinson meant to the club. He was its leader, and set an example for all the players on how to play the game. His MVP that year was awarded for a performance that included a .323 batting average, 32 doubles, 124 runs batted in, and 37 home runs.

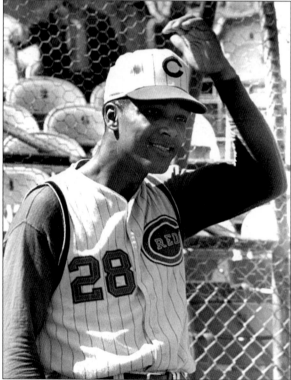

Robinson was a mentor and close friend of another 1960s Reds standout, outfielder Vada Pinson. Pinson became a starter with the Reds in 1959, and led the league in doubles and runs that year. He played for the Reds through the 1968 season before being traded to the Cardinals, and wound up an 18-year major league career with 2,757 hits and 256 home runs.

Pinson was a fine center fielder, but it was his bat that often had the fans cheering. He regularly ranked high in the league in triples, the most exciting at-bat in baseball, and finished his career with 127. Coupled with 305 stolen bases, Pinson's speed on the base paths was thrilling.

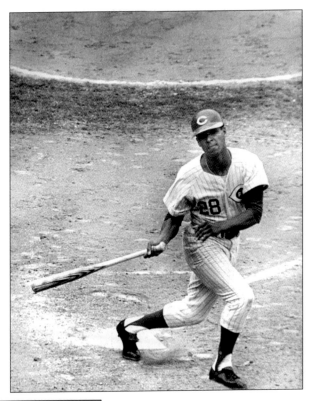

Pitcher Jim O'Toole was also part of that late-1950s crop of new players that would help Cincinnati win the pennant in '61. The lefty's best year with the club was, in fact, in 1961 when his record was 19-9, with a 3.10 earned run average and 178 strikeouts. After a 3-10 season in 1965, he tried to make a comeback to his earlier form, as this photo from spring training in 1966 shows him taking a deep heat treatment for his ailing arm. O'Toole finished his career with the White Sox in 1967, and had a ten-year major league won-lost record of 98-84.

Outfielder Jerry Lynch came to the Reds from the Pirates in December of 1956, and became one of the premier pinch hitters in the game. His role in the 1961 season was pivotal, as he batted .404 with 25 RBI's in his pinch role. The Reds traded him back to the Pirates early in the '63 season. Overall, Jerry Lynch played 13 years in the majors.

Arguably the best pitcher in Reds history, Jim Maloney made his debut with the team on July 27, 1960 in a game he lost 2-0 against Don Drysdale and the Los Angeles Dodgers. He pitched well, however, throwing one-run ball over seven innings, and it was a harbinger of some great games to come. For the rest of that season, and the next two, Maloney was only so-so, but his fastball was prodigious. Not to mention an occasional slippery pitch now and then: Maloney would gain a reputation in the '60s as one of the better spitball pitchers in the game.

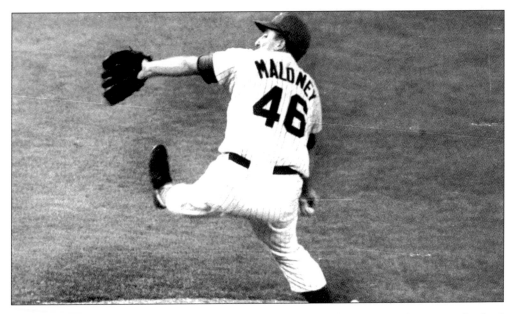

Jim Maloney was a premier power pitcher in baseball during the 1960s. In his career, he fired three no-hitters, five one-hitters and tossed 30 shutout victories. His breakout year was 1963 when he won 23 games and struck out 265 batters. In a game against the Braves on May 21 of that season, Maloney struck out 16 and allowed only two hits in a 2-0 victory. He was on his way. On June 14, 1965 he held the Mets hitless for 10 innings and was credited with his first no-hitter though he lost 1-0 in 11 innings. The two photos here show Maloney in action when he tossed the third no-hitter of his career on April 30, 1969.

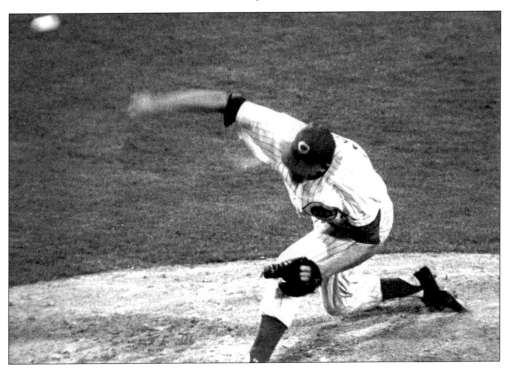

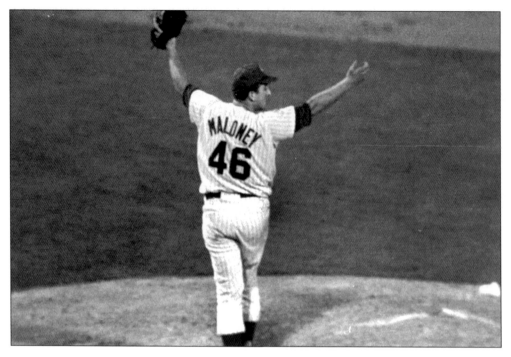

In his no-hitter against the Houston Astros, the Reds won 10-0 at Crosley Field. Maloney fanned 13 batters, drove in a run with a double, and scored twice himself. In these pictures, Maloney holds his arms high in triumph after retiring the final Houston batter in the ninth when he struck out Doug Rader. His teammates then lifted him onto their shoulders in celebration as the Reds faithful cheered from the stands. He topped off the season with another sterling performance against the Astros, a one-hitter he won 3-0 on September 26.

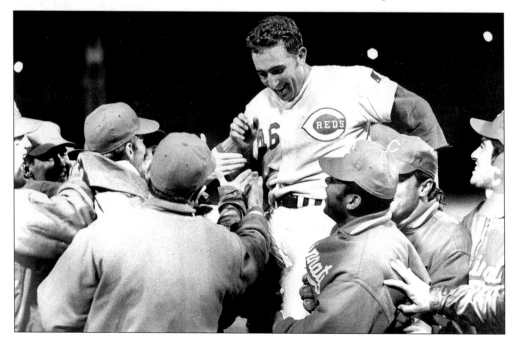

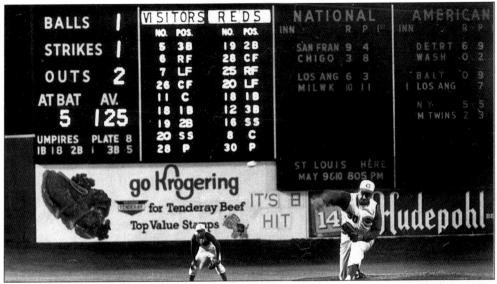

In the 1960 trade that sent popular shortstop Roy McMillan to the Milwaukee Braves, the Reds obtained pitcher Joey Jay, the first major league player to have gone through the Little League system. He had some good years for Cincinnati, especially in 1961 when he won 21 games. This photo shows the May 4 game that year when, after beginning the season with three losses, Jay pitched a one-hitter against the Phillies, winning 4-0. Jay was traded back to the Braves on June 15, 1966, just six days after he pitched a 1-0 shutout against the Phillies. He never won another game.

"Bad trades are a part of baseball. I mean, who can forget Frank Robinson for Milt Pappas for God's sake." So said the character Annie Savoy in the classic baseball film *Bull Durham*. No one ever has forgotten. Mistakenly thinking that Robinson was past his prime and desperate for pitching, Bill DeWitt traded his slugger to the Baltimore Orioles for Pappas, pitcher Jack Baldschun, and outfielder Dick Simpson. It turned out to be one of the worst trades in history. Pappas only lasted with the Reds until 1968. Robinson had an MVP, Triple Crown year with the Orioles as he led them to the World Series championship. He was the first African-American manager in the majors, with Cleveland in 1975, and became a Hall of Famer in 1982.

The submarine pitcher is as rare a breed as the knuckleballer. While the underhand fastball or curve was the pitch of choice in professional baseball's infancy, over the past century only a few hurlers have mastered it to the point where, if it is thrown with a fastball motion it will first rise and then sink. If the pitcher throws it with a twist of the wrist, the submarine curveball rises into the batter. The Reds had a very good submarine-motion pitcher in reliever Ted Abernathy, who they acquired from the Braves for the 1967 season. Abernathy had two good years for the club, winning 16 and losing 10, with 41 saves.

Coach Dave Bristol became the manager of the Reds midway in the 1966 season when Don Heffner was fired on July 13. Just 33 years old, Bristol became the youngest manager in the majors that year. He managed through 1969, guiding the team to fourth, fourth, and third place finishes in his three full seasons. He was fired after the '69 campaign, and replaced with Sparky Anderson. Later, Bristol managed the Brewers, Braves, and the Giants.

Chico Ruiz was a solid utility man for the Reds from 1964 to 1969, dividing his playing time among all the infield positions, and occasionally the outfield. He was traded in the fall of '69 with Alex Johnson to the Angels for Vern Geishert, Pedro Borbon, and Jim McGlothlin. Borbon and McGlothlin had significant roles with the team in its transformation to the Big Red Machine. Ruiz was rather a character, spending a lot of his idle time in the dugout making chains of bubble gum wrappers.

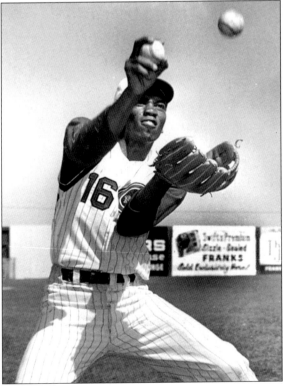

The starting shortstop for the Reds during most of his career in Cincinnati, Leo Cardenas was an excellent fielder. His best year at the plate was in 1965 when he hit 20 home runs and 81 runs batted in. At the end of the 1968 season, Cardenas was traded to the Minnesota Twins for pitcher Jim Merritt, who would be a 20-game winner for the team in 1970. In this photo of Cardenas, he is trying to field three balls at once. The third ball, shown in the upper right, fell to the ground.

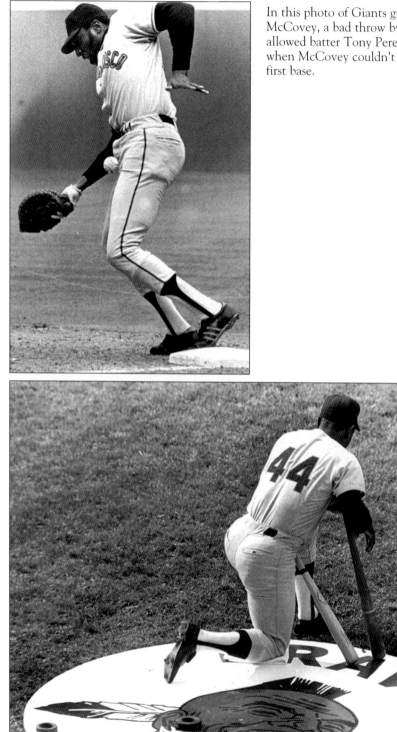

In this photo of Giants great Willie McCovey, a bad throw by the third baseman allowed batter Tony Perez to reach safely when McCovey couldn't handle the ball at first base.

All-time home run leader Henry Aaron of the Braves waits in the on-deck circle at Crosley Field, waiting for his turn at bat.

In another photo of Aaron, the great slugger takes a short lead off base, held there by Reds first baseman Lee May.

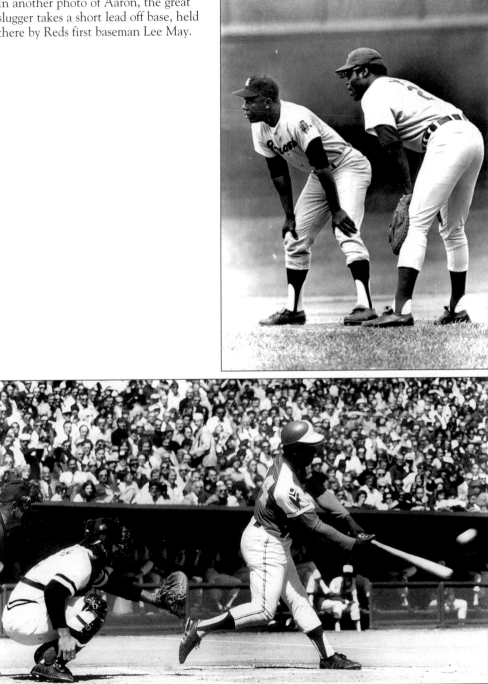

Aaron would have some great hits in Cincinnati, both at Crosley Field, and in his continuing pursuit of the home run crown in Riverfront Stadium after the Reds moved there in 1970. On May 17, 1970, he collected his 3,000th hit off Wayne Simpson at Crosley. He would clout his 714th round tripper, tying Babe Ruth's lifetime mark, on April 4, 1974 when he hit a homer in the first inning of Opening Day off Reds pitcher Jack Billingham.

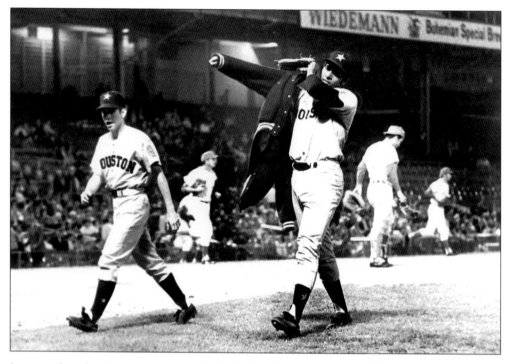

Just one day after Jim Maloney tossed his third no-hitter against the Houston Astros, winning 10-0 on April 30, 1969, Astros pitcher Don Wilson came back the next night on May 1 to do the same against the Reds. He fanned thirteen batters on his way to a 4-0 victory. The top picture shows him walking off the mound between innings, and the bottom photo shows Wilson pitching to Red Alex Johnson in the bottom of the ninth with two out. Working the count to 1-2, he got Johnson to fly out to center to end the game.

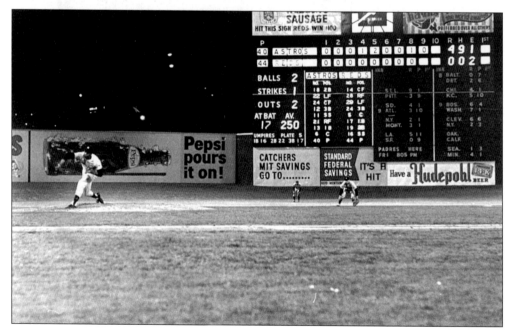

Wilson signs autographs for the Crosley Field fans after the game. Don Wilson was a workhorse of a pitcher for the Astros from 1966 to 1974, regularly throwing over 200 innings a year. The year he pitched this no-hitter, he had a record of 16-12.

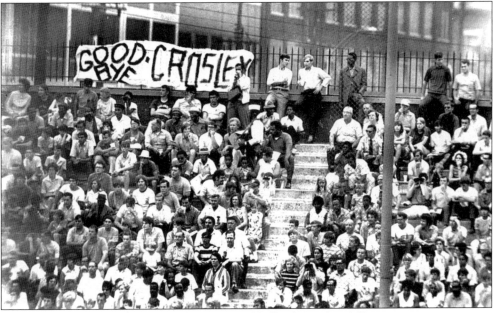

Wilson's was the last no-hitter thrown in a storied ballpark. As the 1969 season was coming to an end, the fans and the team made plans for the move to the Riverfront. This photo is of the last game played at Crosley Field on June 24, 1970, as the fans bid adieu to a Cincinnati landmark.

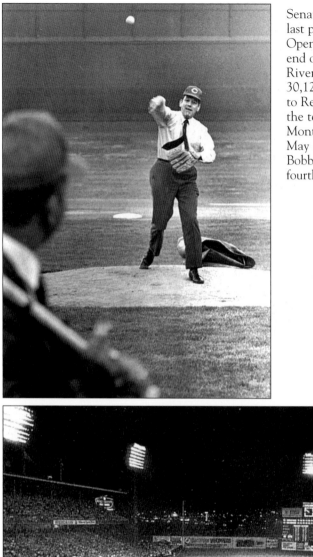

Senator Robert Taft Jr. tosses out the last political pitch at Crosley Field on Opening Day, April 6, 1970. By the end of June, the Reds would be in Riverfront Stadium. Before a crowd of 30,124, Taft gave way on the mound to Reds pitcher Jim Merritt, who led the team to a 5-1 victory over the Montreal Expos. First baseman Lee May and outfielders Bernie Carbo and Bobby Tolan all hit home runs in the fourth inning.

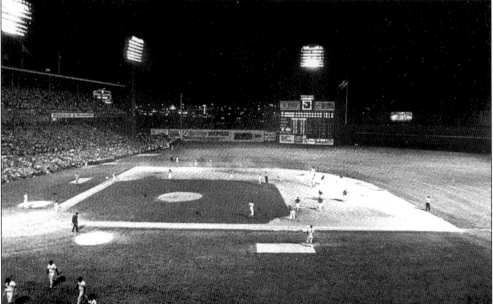

More than 28,000 fans turned out for the final game at Crosley on June 24, 1970 to see the Reds defeat the San Francisco Giants 5-4. The victory was suitably dramatic for the occasion: Johnny Bench and Lee May hit back-to-back homers in the bottom of the eighth inning to rally the team from a 4-3 deficit.

At the conclusion of the game, the groundskeepers trotted onto the field and dug up home plate, whereupon it was lifted by helicopter and flown to its new home in Riverfront Stadium.

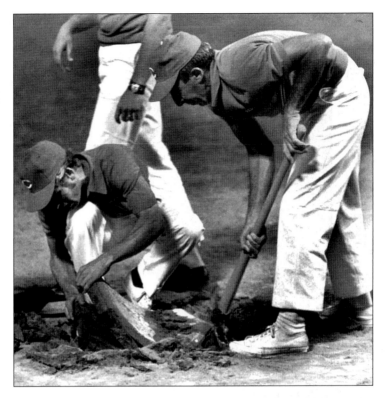

And as for Crosley Field? Before its eventual demolition, it would be used as an impounding lot by the Cincinnati Police Department.

Where baseball had been played for nearly a century quickly became just a part of community memory. As automobiles took the place of fans and players, the view from Interstate 75 and Crosley's neighboring streets was one of weeds and a run-down neighborhood. Urban development plans would eventually result in a sprucing-up of the area with small businesses, but first the old ballfield had to be demolished. Twenty-two months after the final game, crews moved in to do the deed. Pete Rose Jr. sat on his dad's lap to ceremoniously pull the lever that sent a wrecking ball into the right field stands.

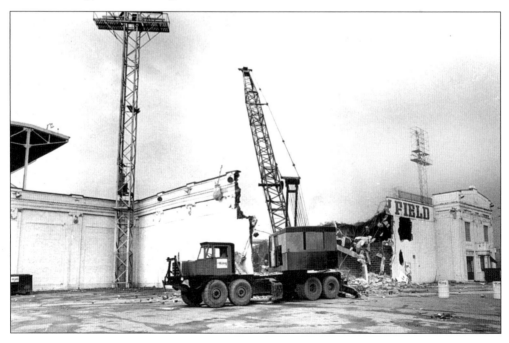

THREE

The 1970s to 1985

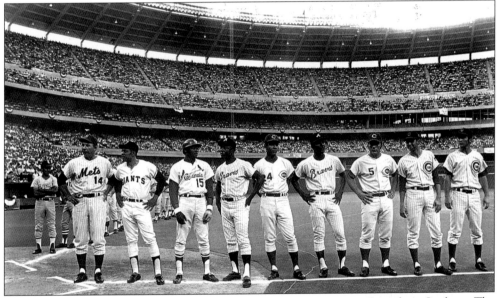

On July 14, 1970 the All-Star Game was held in Cincinnati at its new Riverfront Stadium. The gathering symbolized not only a new era for the Reds but one for baseball as well, as several new ballparks opened. The style of play would be different as well, accommodating artificial turf infields. One style remained constant: Pete Rose bowled over Indians catcher Ray Fosse to score the winning run in the 12th inning. This photo shows the National League lineup of, from left to right, Mets manager Gil Hodges, Willie Mays, Dick Allen, Hank Aaron, Tony Perez, Rico Carty, Johnny Bench, Don Kessinger, and Glen Beckert.

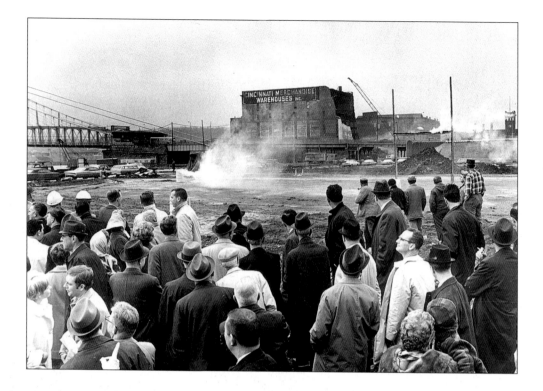

Riverfront Stadium's construction began on February 1, 1968 with a groundbreaking ceremony on the river. A small gunpowder charge exploded and burned with smoke at the location of each of the bases for the baseball layout of the stadium, and at the crossbar of a goalpost set up to represent the football tenants, the new Cincinnati Bengals. But before actual construction was underway, a worker tried his chances at the plate while Johnny Bench waited for the pitch. The hardhat may have served the batter well, but the board made it a little tough to pull the inside pitch.

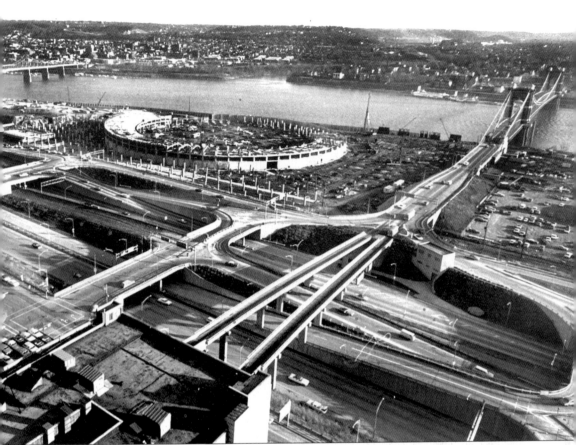

Bordered by Cincinnati's highway system and the river, the stadium rapidly began to take shape.

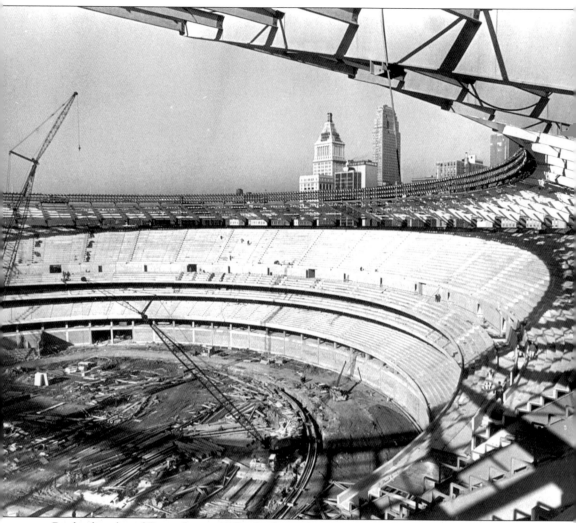

By the first day of December in 1969, the form of Riverfront Stadium was well underway. The Cincinnati skyline is in view behind the ballpark's upper girders.

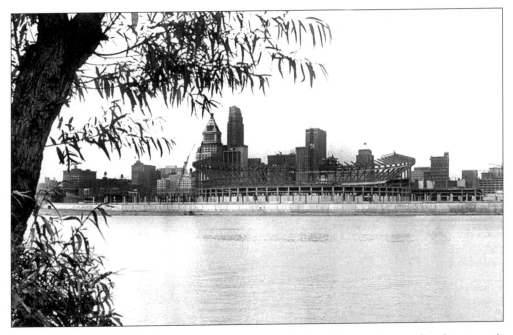

After the completion of the stadium, there was a new look to the riverfront and to Cincinnati's skyline. And the round concrete structure, situated in a veritable island of concrete parking and bordered by highways, fit the sports aesthetic of its time. Given the cultural, political, and racial turbulence of the 1960s and 1970s, ballparks like Riverfront provided a notion of safety for the prevailing numbers of Reds fans, who came from outside the city limits. Access was directly to the stadium to see the game, with quick access for the journey home. A highway separated Riverfront from the city, and thus from city life, despite the pedestrian bridges joining the two. It was indeed safe, and sterile. Even the artificial turf provided a semblance of unchanging security in a polyester world.

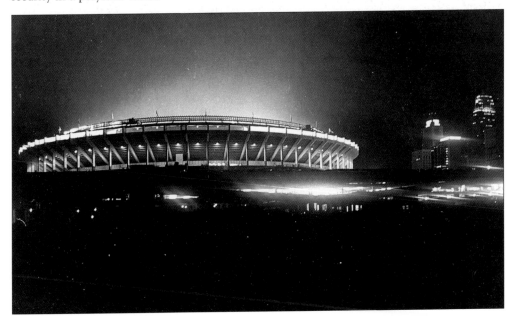

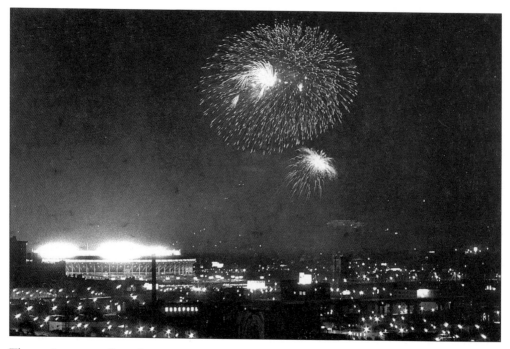

The excitement at Riverfront Stadium in the years of the Big Red Machine could be seen and felt on a summer's evening when the Reds were victorious. The tradition started to send off loud, brilliant fireworks whenever a Red hit a home run, or at the conclusion of a Reds victory. The stadium was also designed to be a public venue that could be used by more than just the Reds and Bengals. Rock concerts and religious gatherings also took advantage of the stadium's location and capacity. The bottom photo shows the early arrival of delegates for a Jehovah's Witness convention.

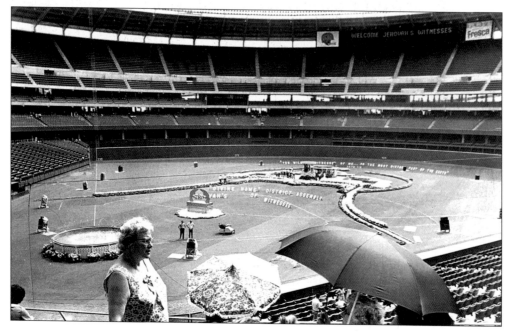

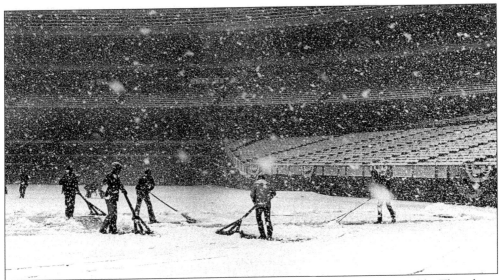

Counting on good weather for Opening Day in Cincinnati is always a dicey gamble. There have been days warm and filled with sunshine, others with cold rain, sleet, and snow—and some with all of that in one afternoon. This photo is of the April 6, 1977 Opening Day when the city was blanketed with four inches of snow that morning. Crews went to work in the stadium and the field was cleared in time for the start of the game at 2:30. However, the Reds' bats remained cold as the team lost to the San Diego Padres by a score of 5-3.

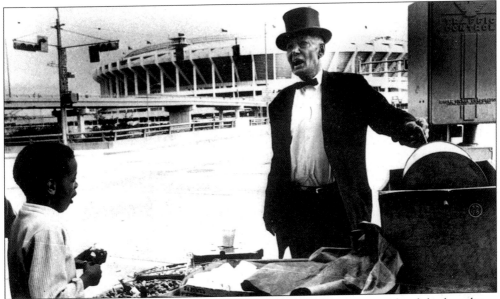

Sometimes the strongest baseball memories are of people who were outside of the base lines. Peanut Jim Shelton always referred to his peanut wagons as his "Cadillac" pushcarts. For half a century he sold his wares outside the walls of Crosley Field as fans walked up to the turnstiles, and then after the closing of Crosley, Peanut Jim followed the Reds down to Riverfront Stadium. He set up shop on the walkway leading over to the stadium's plaza. His trademark stovepipe hat endeared him to fans over generations. In 1982, Shelton died at the age of 93, and a walkway was named in his honor.

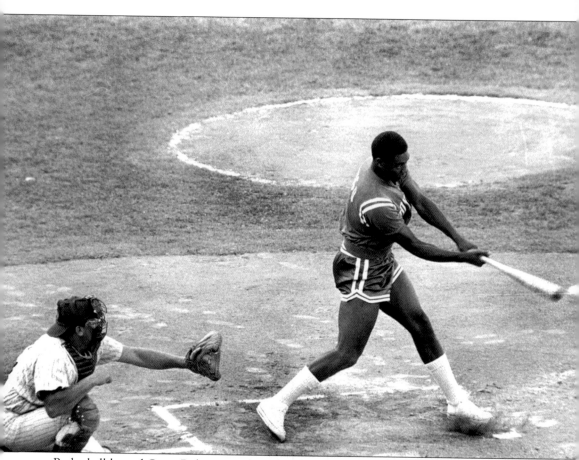

Basketball legend Oscar Robertson takes his turn at bat in a celebrity game held at Riverfront Stadium in the early '70s. As a collegiate star at the University of Cincinnati, Robertson was the National Player of the Year in 1958, '59, and '60. He went on to a Hall of Fame career with the hometown Cincinnati Royals and the Milwaukee Bucks.

George "Sparky" Anderson was named the Reds manager on October 9, 1969. A longtime favorite of team general manager Bob Howsam for whom he managed in the St. Louis Cardinals minor league system, Anderson only played one season in the majors, with the Philadelphia Phillies in 1959. Sparky was the perfect man for what many people think of as the perfect team: the Big Red Machine. He would lead them to back-to-back World Series championships in 1975 and 1976. His record from 1970 to 1978 was 863 wins and 586 losses.

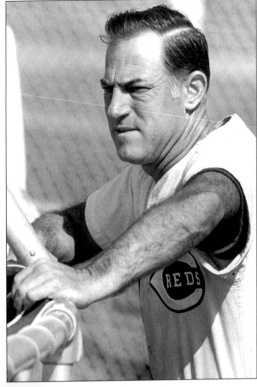

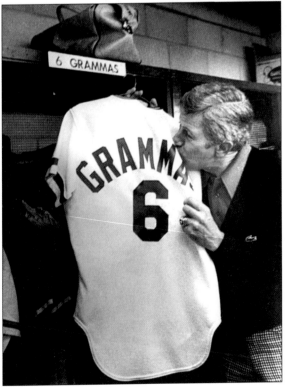

One of Anderson's finest coaches was Alex Grammas, who worked with Sparky from 1970 to 1975, and then came back to the club in '78, his appreciation being shown in this photo of him kissing his uniform. During his own playing days, Grammas was a utility infielder for the Reds from 1956 to 1958.

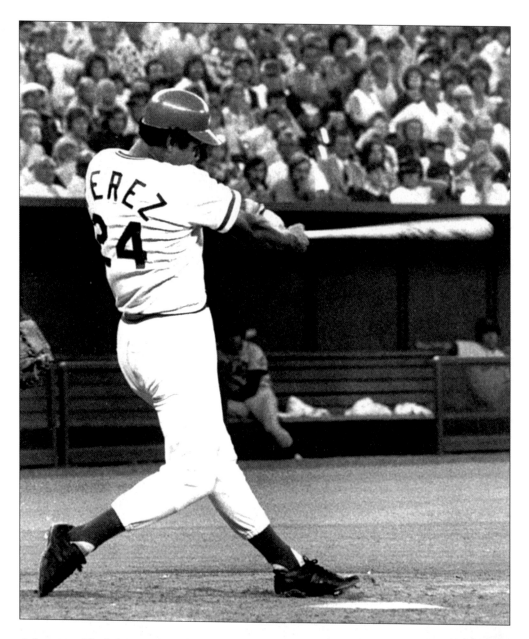

A favorite of Reds fans, and a stalwart on the team since his arrival in Cincinnati in 1964, Tony "Doggie" Perez was one of the great players of the 1970s. During his career with the team, Perez had 1,934 hits, 287 home runs, 1,192 runs batted in, and 682 extra base hits—all in the all-time top five of these Reds categories. The Cuban native began his career at third base, but an erratic throwing arm made him a better bet at first. Perez was nothing if not reliable at the plate: from 1967 through 1976 for the Reds, he averaged over 90 runs batted in each season. He briefly managed Cincinnati in 1993, and then in 2002 he was inducted into the National Baseball Hall of Fame. These photos show his power in connecting with the baseball, a slide into home against the Phillies (though he was never accused of being fleet of foot!), and standing with his wife and children as he took the oath of citizenship in the United States.

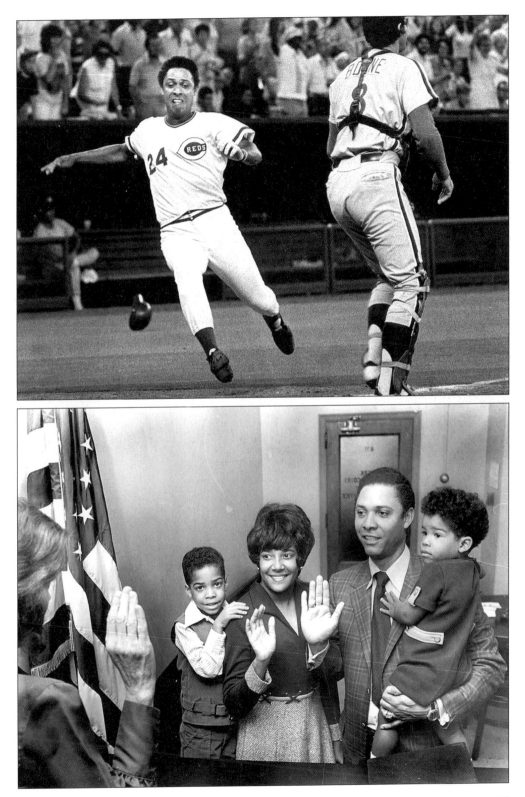

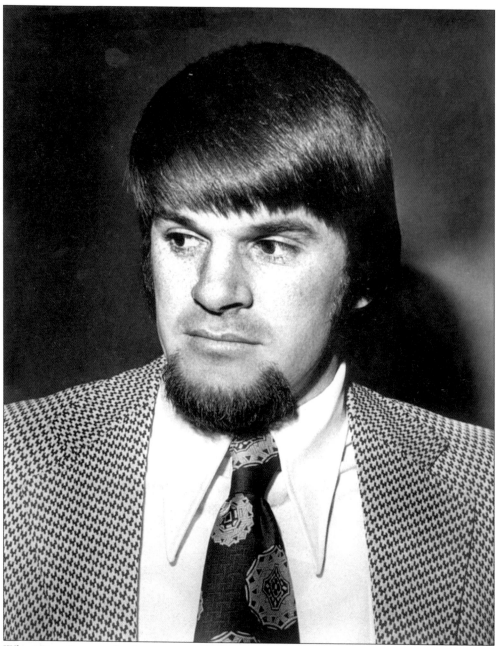

When Pete Rose made the majors in 1963, he quickly became known as much for his brush crewcut as he was for his all-out style of play. Fashions were invented and re-invented in a decade of renewed individualism and freedom, and he often quipped that as long as there were barbers in Cincinnati, he would have a crewcut. Well, the times they do change. In the 1970s, Rose decided to alter his style after all, and his off-season appearance one winter featured a goatee and pageboy haircut. The decades since have been marked by a variety of Rose hairstyles, including the late, but not lamented, rat-tail.

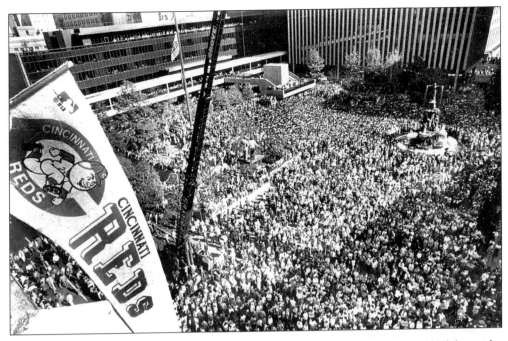

In October 1972, fans crowded on Fountain Square in downtown Cincinnati to celebrate the team's capture of the National League pennant. In one of the most exciting championship series in history, the Reds bested the Pirates in five games with a 4-3 win in the ninth inning—an inning they came into on the short end of a 3-2 score. Johnny Bench led off the final frame with a home run, and then after singles by Tony Perez and third baseman Denis Menke, George Foster pinch-ran for Perez, moving to third on a sacrifice fly by Cesar Geronimo. He scored the game-winning run when the Pirate reliever threw a wild pitch. The Reds were in the World Series for the second time in three years. The next season, the championship banner was unfurled at Riverfront Stadium.

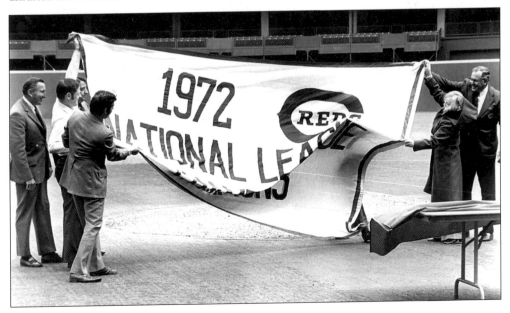

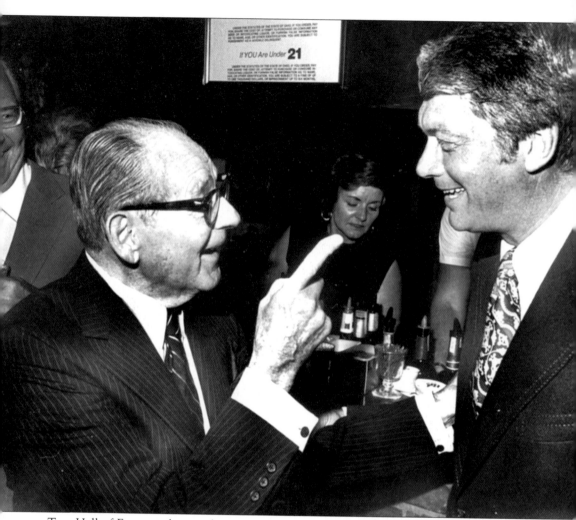

Two Hall of Fame pitchers with strong Cincinnati ties get together at a banquet during the Reds glory years. Waite Hoyt (left), who made the Hall on the strength of some great years with the Yankees, was the Reds broadcaster from 1942 to 1965, and briefly again in 1972. Jim Bunning (right) attended St. Xavier High School and Xavier University in Cincinnati before embarking on his pitching career that saw him have great years with the Tigers and Phillies. Now a United States senator from Kentucky, Bunning tossed no-hitters in both the American and National Leagues, and won more than 100 games in both leagues as well.

When the Reds brought up Gary Nolan to the majors in 1967, they had great hopes that he would have a very long, productive career. After all, he was only 18 when he made his debut on April 15 that year, beating the Astros 7-3. Nolan had a wonderful rookie season, finishing 14-8. His next two years saw records of 9-4 and 8-8, but in 1970, Nolan won 18 against just 7 losses to help lead the Reds to the pennant and into the World Series. Overall, he won 110 games for the Reds in ten seasons.

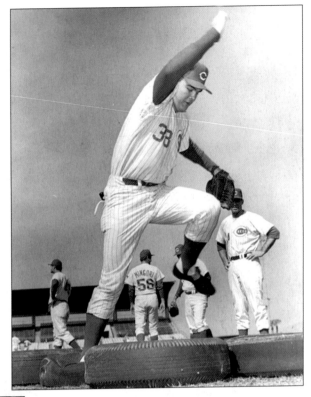

Enthusiasm was just as high for Wayne Simpson, a fireballing righthander. Simpson made the team in 1970. At the All-Star break, the rookie pitcher was already 13-1, but on July 31, he tore his rotator cuff in a game against the Cubs. Simpson finished the season with a 14-3 mark, but for all intents and purposes his career was over. He struggled over the next several seasons with a variety of teams, but retired for good in 1977. Some folks thought part of the blame for Simpson's arm trouble was Sparky Anderson pitching him too much.

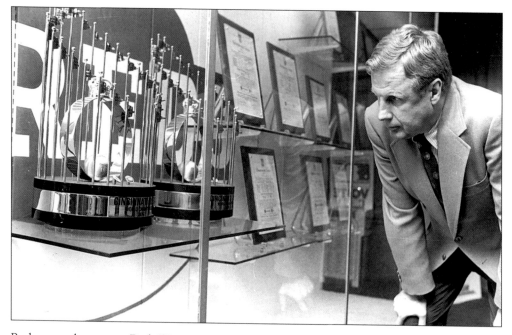

Reds general manager Dick Wagner was named as a replacement for Bob Howsam, who had decided to enter into semi-retirement. Howsam brought Wagner to the Reds in 1967, and together they built the Big Red Machine. But Wagner was often vilified by the fans, who found him arrogant and standoffish. Wagner was also blamed for the breakup of the Machine when he traded Tony Perez after the '76 season, fired Sparky Anderson in 1978, and didn't sign Rose to a new contract, allowing him to go to the Philadelphia Phillies as a free agent. Rose and Wagner often had serious differences of opinion, and Rose being the hometown hero, the fans tended to side with him. Wagner was replaced himself in 1983 when Howsam was convinced to return. These two photos show Wagner looking at the Reds' World Series trophies of '75 and '76, and of a short-lived idea Wagner had of putting cheerleaders in the stands.

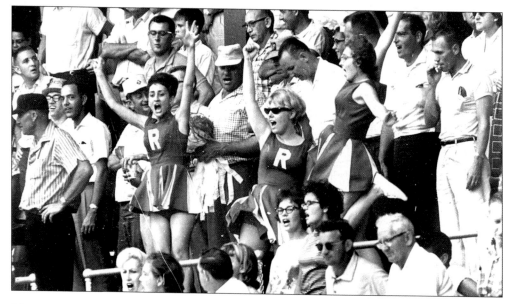

In more jubilant scenes, Johnny Bench and Sparky Anderson celebrate the 1972 National League flag, and in the World Series against the Oakland A's that followed, the Reds wives cheer them on when the Reds posted a 1-0 victory on October 18. From left to right are the wives of Darrell Chaney, Denis Menke, Tony Perez, David Concepcion, and Cesar Geronimo.

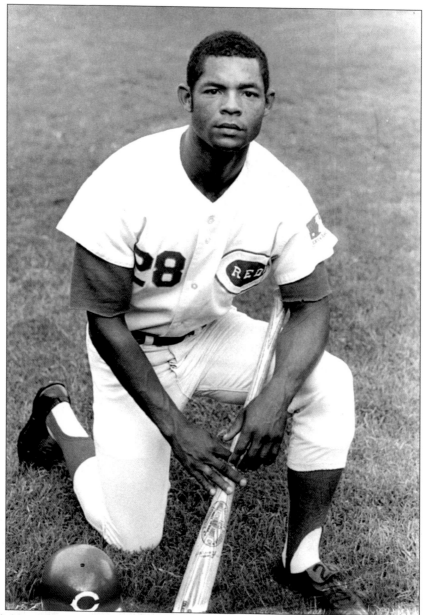

In outfielder Bobby Tolan's distinctive batting stance, he held the bat high above his head and shoulders and then whipped it at the pitch. In October 1968, the Reds sent Vada Pinson to the St. Louis Cardinals in a trade for Bobby Tolan and pitcher Wayne Granger. The trade worked out well for the Reds. Both Tolan and Granger were productive, but Tolan's tenure with the Reds was an injured and stormy one. During the winter months following the 1970 season, Tolan ruptured his Achilles tendon while playing basketball for the Reds' off-season team. On May 7, he injured it again, and missed the entire year. The Reds front office put the kibosh to the charity basketball team, but Tolan's days with the Reds were numbered. On September 27, 1973, he was suspended by the club for insubordination, and while there were many incidents that led to the suspension, what the fans remember is that Tolan grew a beard in opposition to the Reds' grooming policy.

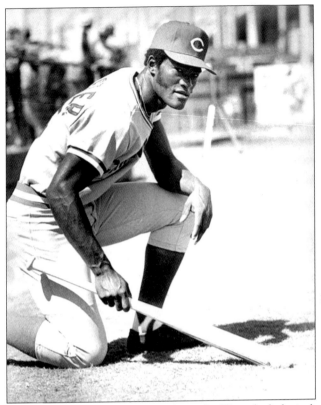

George Foster was a deceptive power hitter with the Reds. Though slight in build, his muscular forearms and quick wrists allowed him to be a premier home run hitter: in 1977 he clobbered 52 homers and knocked in 149 runs. In the bottom image from the August 21, 1974 game against the Phillies, pitcher Jim Lonborg had been firing low balls at the Reds for most of the game. This pitch from the hurler, however, was up and in, causing Foster to fall away as catcher Bob Boone grabbed the ball. Umpire Dutch Rennert apparently saw it the same way Foster did—he called it a ball.

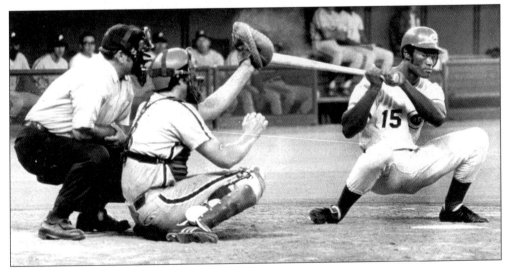

Lee May played for the Reds from 1965 through 1971, enjoying his one Reds pennant-winning year in 1970 when he hit 34 home runs and knocked in 94 runs. He was a big part of the greatest trade in Reds history when, on November 29, 1971, he was sent to the Houston Astros along

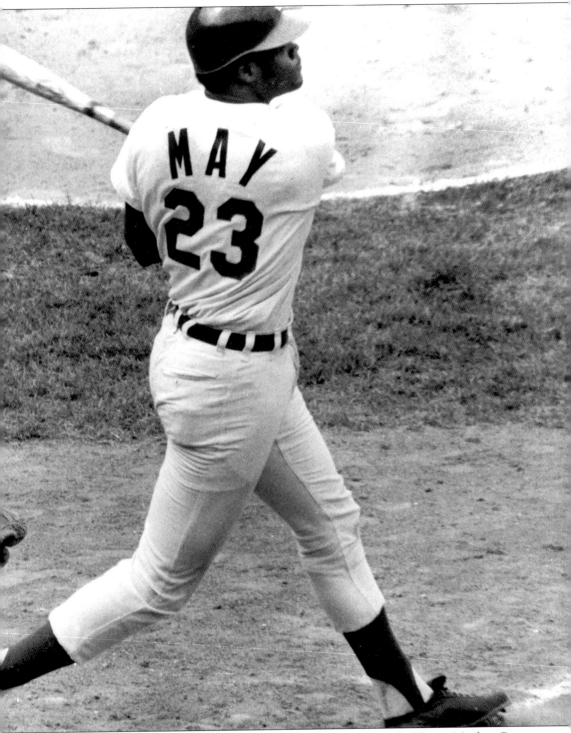

with infielders Tommy Helms and Jimmy Stewart in exchange for Denis Menke, Cesar Geronimo, Ed Armbrister, Jack Billingham—and Joe Morgan. The trade would make the Big Red Machine a force for the next four years when they won two World Series.

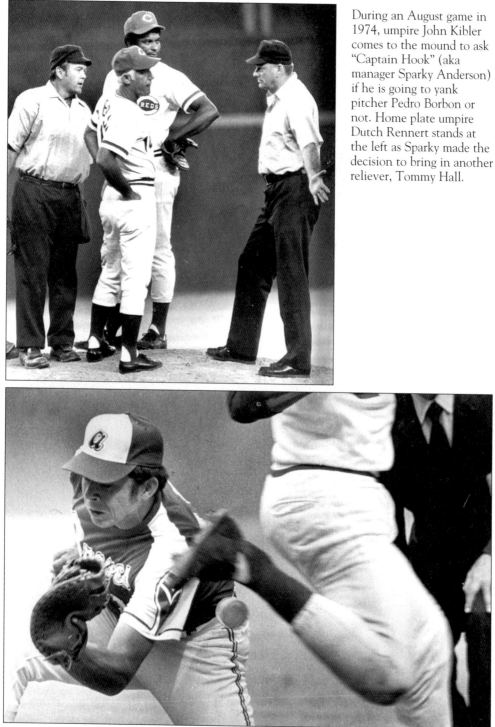

During an August game in 1974, umpire John Kibler comes to the mound to ask "Captain Hook" (aka manager Sparky Anderson) if he is going to yank pitcher Pedro Borbon or not. Home plate umpire Dutch Rennert stands at the left as Sparky made the decision to bring in another reliever, Tommy Hall.

Playing against the Atlanta Braves, outfielder Cesar Geronimo made it safely to first base after striking out. The third strike was dropped by the catcher, who then tried to throw it to first baseman Darrel Evans for the put out. The throw eluded Evans and Geronimo was safe.

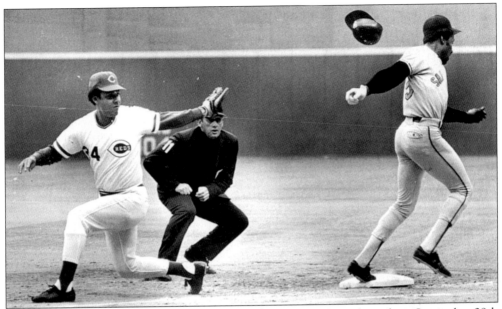

As the season wound down in 1974, San Francisco came to Riverfront for a September 29th game. Giants outfielder Bobby Bonds bounced one high off the turf to shortstop David Concepcion, whose hurried throw pulled Tony Perez off the bag at first. Umpire Andy Olsen made the call.

Tony Perez is hit in the shoulder by a pitch during a game at Riverfront. After Dick Wagner traded Perez to the Montreal Expos in 1977, he went on to have eight more major league seasons, including winning a World's Series with erstwhile teammate Pete Rose and the Phillies in 1983, and having an excellent year for the Boston Red Sox in 1980, hitting 25 home runs with 105 runs batted in. Perez finished his 21-year career back with the Reds in '84, playing in 71 games.

Ken Griffey, during a spring training game in 1978 against the New York Mets, is tagged out when he is caught off second base. Griffey had singled off pitcher Tom Seaver, and then stolen second. On the next pitch, Seaver whirled and threw to shortstop Bud Harrelson, who slapped the tag on Griffey. Griffey played for Cincinnati from 1973 to 1981, before going to the Yankees in 1982. He then returned to the Reds from 1988 to '90, and in '97 became a coach for Cincinnati.

(*Right*) In a '74 game against the Dodgers, Dave Concepcion is the victim in a blown squeeze play when pitcher Jack Billingham failed to get the bunt down as the Reds shortstop tried to score from third base. Catcher Steve Yeager makes the tag.

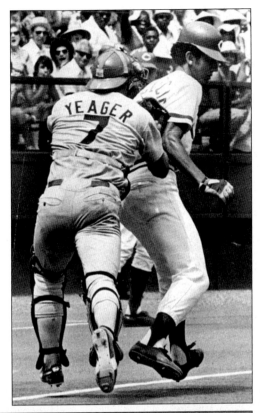

(*Below*) Concepcion made his debut with the Reds on Opening Day, April 6, 1970. Using the artificial surface of Riverfront Stadium to his advantage, he became expert at snagging ground balls at deep shortstop, whirling and getting the ball to first base on a hard bounce off the turf. In this view from the final years of his career during spring training in 1984, Concepcion takes a throw from catcher Brad Gulden during a game against the Los Angeles Dodgers, throwing the tag down on Mike Marshall, who attempted to steal second base.

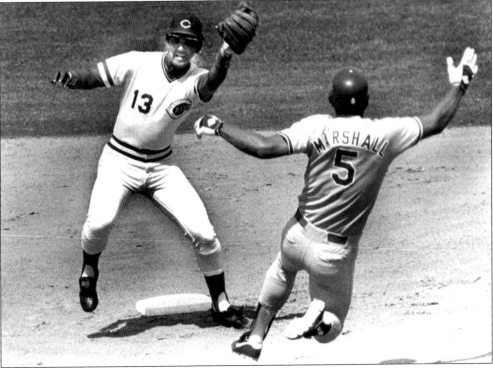

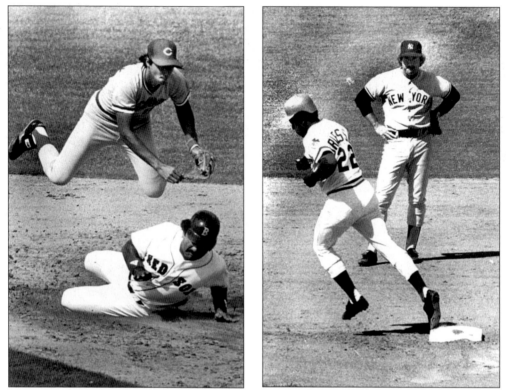

Many fans think that the 1975 and 1976 Reds teams were some of the greatest in the history of the game, and a strong case could be made for the '76 squad being the best ever. In 1975, the Reds swept through the National League, winning the their division by 20 games, and conquering the Pirates for the pennant. Their World Series victory over the Red Sox was one of the most thrilling in memory as they went the full seven games. The following year, they handily won the Western Division, swept the National League playoffs, and then swept the New York Yankees, four games to none, in the World Series. Both years, Joe Morgan won the National League Most Valuable Player Award on teams that were heavily talented at every position.

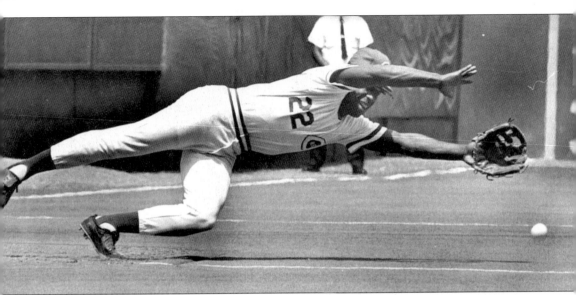

During a '74 game, first baseman Dan Driessen dives for a ball hit by the Dodgers' Jimmy Wynn. Driessen played for the Reds from 1973 to 1984, and in his two World Series with the team in '75 and '76 batted .313.

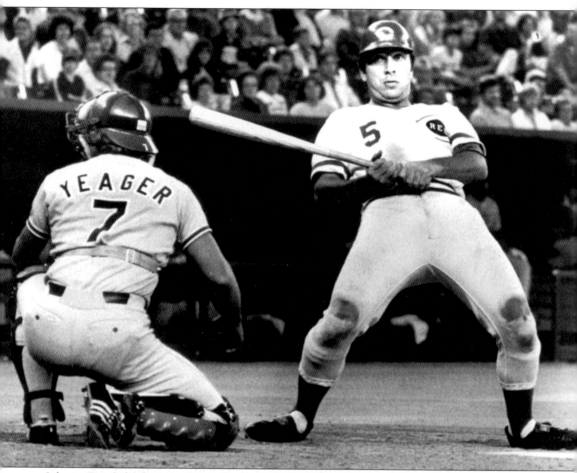

Johnny Bench backs away from a high inside pitch during a game against Los Angeles. From the posture of Dodgers catcher Steve Yeager, the pitch apparently passed by him as well.

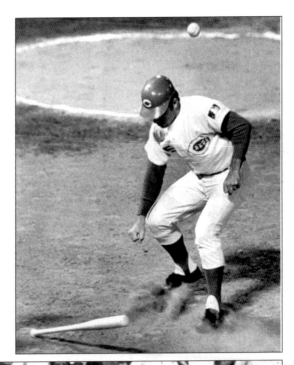

The top photo shows another inside pitch to Bench, but this time he was plunked in the back by Don Wilson. The bottom photo shows the Reds in action once more against the Dodgers. In a July 4th game in 1974, Bench beats the throw home to score the first run of the game. That year the Reds finished second to the Dodgers in the Western Division after staging a comeback that ended two weeks before the season's end. Bench led the Reds that year with 33 home runs and 129 runs batted in.

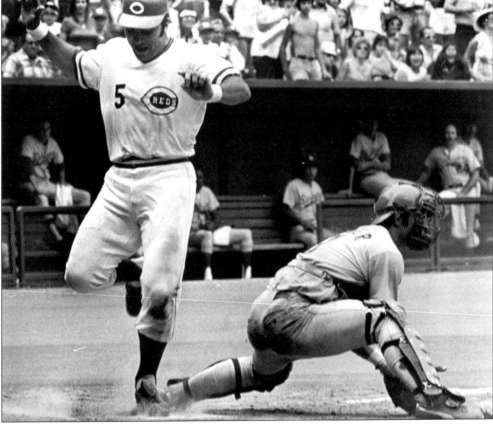

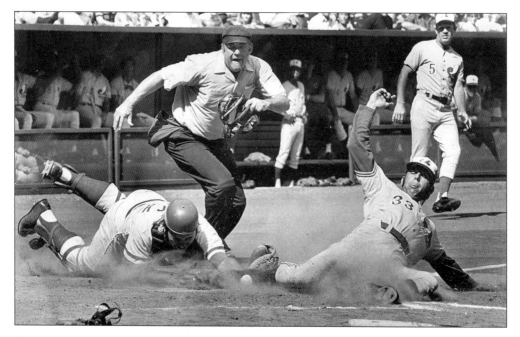

Trying to score on Bench when the throw came into the plate was a risky endeavor as he was arguably the best defensive catcher of all time. In the top photo, Expo Ron Hunt does in fact score when Hal Breeden singled to send Hunt home from second base. Former Reds manager Dave Bristol was the Expos third base coach at the time, and can be seen in the upper right as he was watches umpire Paul Pryor make the call. In the bottom photo, Phillie Mike Schmidt does not have such luck as Bench tags him with the ball in his hand as Schmidt tried to sweep his hand across the plate. Phillie shortstop Larry Bowa looks on.

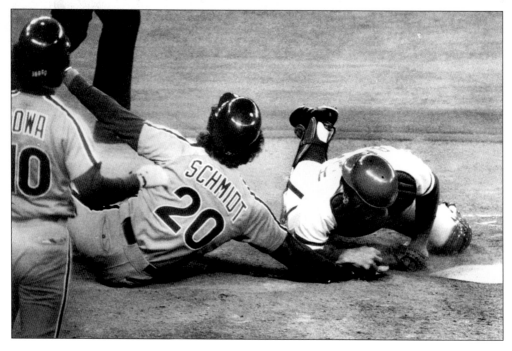

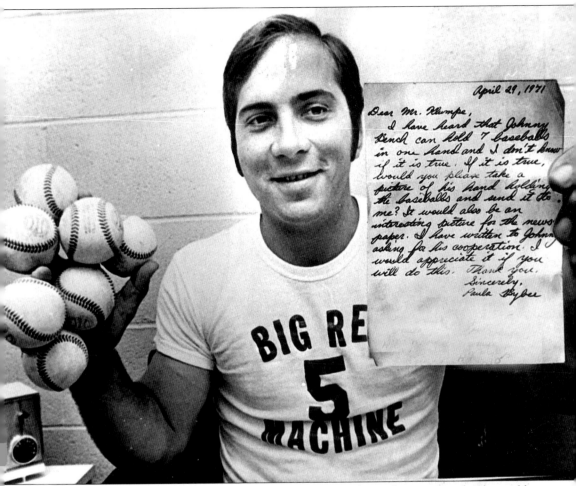

The handwritten note reads:

April 29, 1971

Dear Mr. Klumpe,

I have heard that Johnny Bench can hold 7 baseballs in one hand and I don't know if it is true. If it is true, would you please take a picture of his hand holding the baseballs and send it to me? It would also be an interesting picture for the newspaper. I have written to Johnny asking for his cooperation. I would appreciate it if you will do this. Thank you.

Sincerely,
Paula Bybee

The size of Bench's hands was something to behold. The popular media story was that he could hold seven baseballs in one hand, so one fan wrote a letter to him, asking if the tale was true. It was. In 1971, Bench indulged Paula Bybee by grasping seven baseballs for the camera.

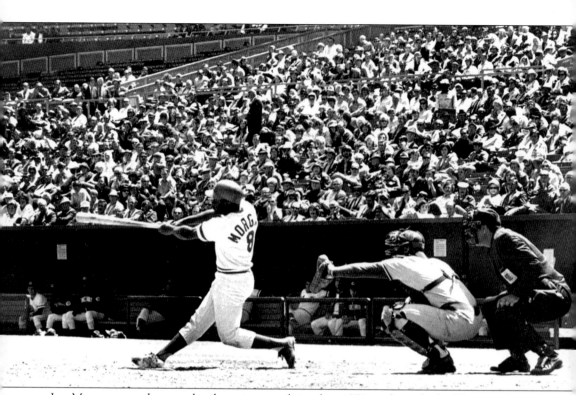

Joe Morgan turned out to be the prime catch in that 1971 trade with the Houston Astros. Morgan had his best seasons with the Big Red Machine, and defined the new breed of second baseman that could hit with power and steal bases. His batting stance was unforgettable: before the pitch he would pump his left arm a few times like a chicken flapping a wing. The movement was a conditioned reminder to hold his bat up.

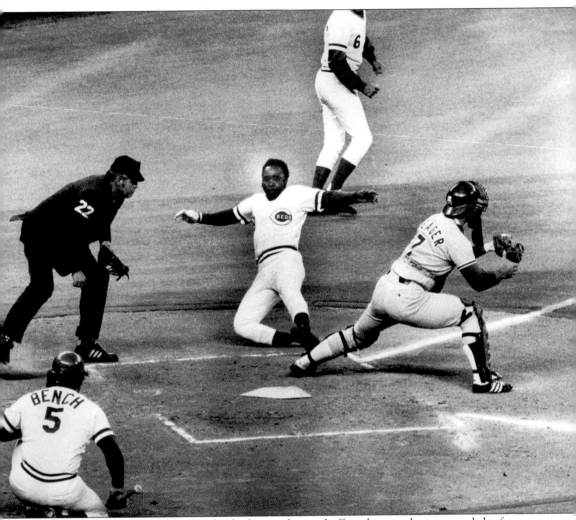

Morgan's speed on the basepaths also had a conditioned effect, but on the team and the fans. It was no matter if the team was behind as the game stretched to the eighth and ninth innings. The expectation was that the team would come up with a way to score and win, with rallies often started by a powerful home run or Morgan's finding a way to get on base. In this photo, he scores from second on a single, as Bench watches him slide into home.

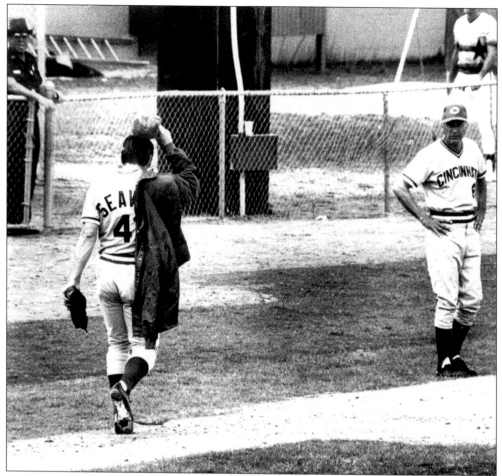

On June 15, 1977, the Reds pulled off an astounding trade when they acquired future Hall of Famer Tom Seaver from the New York Mets. The Reds sent Pat Zachry, Steve Henderson, Dan Norman, and Doug Flynn to the Mets for Seaver, who would complete the '77 year with the Reds by posting a 14-3 record. This photo is of him at spring training the following year.

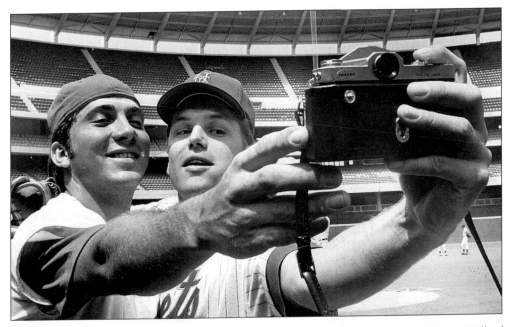

Seaver fit in well with the Cincinnati team. In the '70s, the Reds had some future Hall of Famers, and they all knew what it took to win. They also knew that team chemistry was a large part of their particular success. The Reds would not win a World Series during Seaver's years with them, but the excitement he brought to the team kept the fans enthusiastic. In these two photographs, Seaver is shown with Bench, taking their own picture before a game, and trying to work a crossword puzzle in the clubhouse.

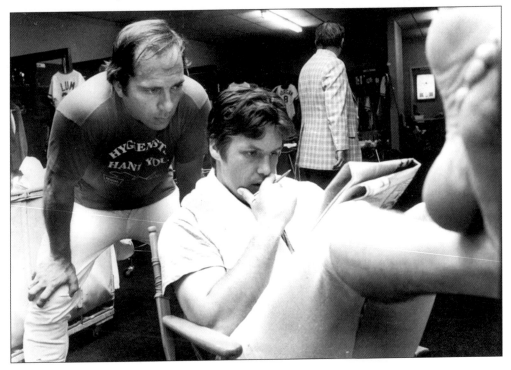

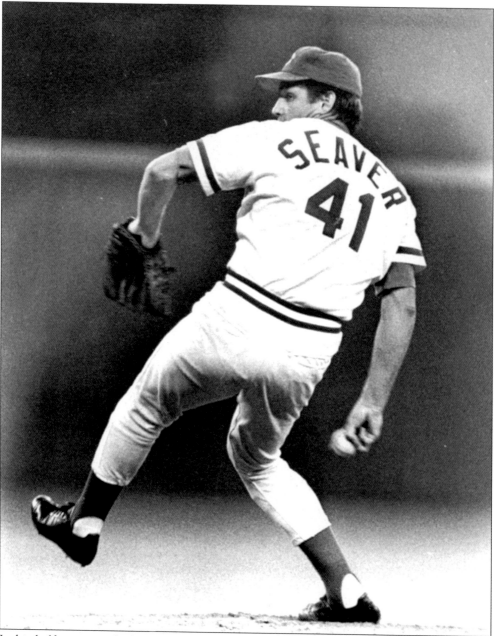

In his half-season with the Reds in 1977, Seaver gathered fourteen wins against only three losses in twenty starts. Coupled with his record of 7-3 in 13 starts with the Mets before the trade, he was a 20-game winner for the fifth time, with a total record of 21-6.

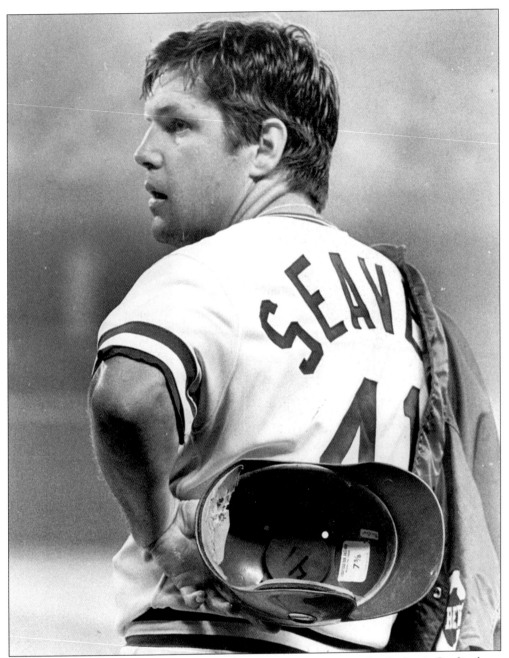

While he was with Cincinnati, Seaver also fired a no-hitter against the St. Louis Cardinals on June 16, 1978, winning 4-0. From 1977 until he went back to the Mets in 1983, Seaver won 75 games for the Reds.

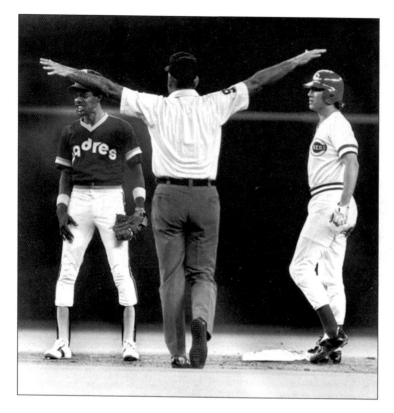

In 1978, the Reds attempted to restore some speed to their team when they acquired outfielder Dave Collins from the Seattle Mariners. Collins played for the Reds for four seasons and stole 175 bases.

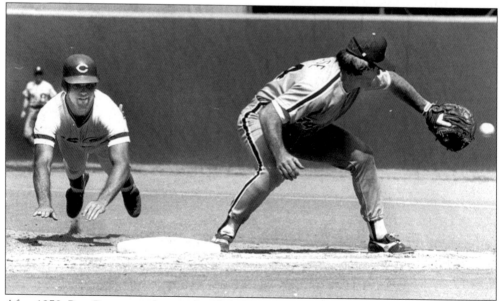

After 1978, Pete Rose moved on to the Philadelphia Phillies where he anchored first base, and mentored star Mike Schmidt. Rose had the same effect on Phillie baseball as he did on Reds baseball: he made the rest of the team winners.

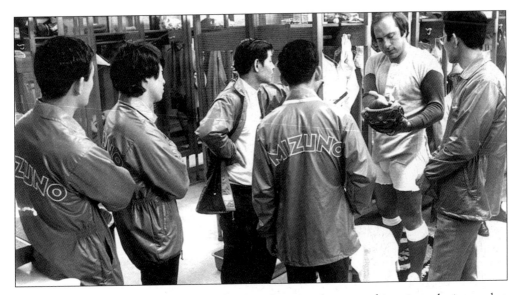

In the 1970s Japanese sporting goods manufacturers began making inroads into what traditionally had been an American industry of bats and gloves. Johnny Bench is shown here with representatives of the Mizuno company, examining one of their new catcher's mitts. The '70s would also see a closer connection between American and Japanese baseball interests. The two countries have always had considerable ties in the sport, but with some additional post-season barnstorming by American teams, an excitement worldwide over Japanese slugger Sadaharu Oh, and the development of players that would see the beginning streams of Asian talent in the Major Leagues in the '90s and in the 21st century, the '70s proved to be a time of growth. In the bottom photo, Sparky Anderson chats it up with Japanese reporters.

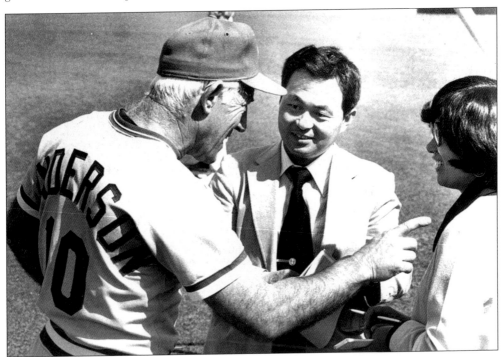

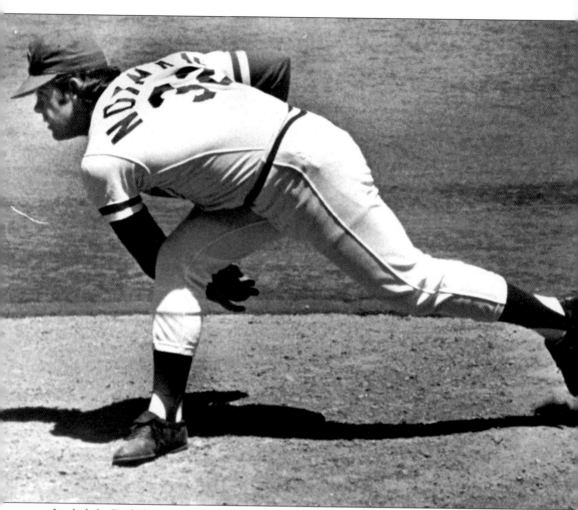

Little lefty Fred Norman came to the Reds in a mid-season trade with the Padres in 1977 that sent Gene Locklear to San Diego. In his first start, Norman shut out the Pirates, 6-0, before the hometown Riverfront crowd. He quickly became a favorite in Cincinnati through his stint with the club that lasted until 1980. Standing only five feet, eight inches, Norman was someone the everyday guy could identify with, a hard worker with the tools he had, and he fit into the personality of the city of Cincinnati very well.

Longtime equipment manager Bernie Stowe hangs up the uniforms of pitcher Bill Bonham in the top photo, and in the bottom picture, he hands a slightly different Reds uniform to Johnny Bench. In the 1978 spring training campaign, the Reds decided to go Irish for their March 17 game. As part of the St. Patrick's Day celebration, the team wore uniforms with green trim instead of red, and a shamrock on the left sleeve. Bench's comment to Stowe's presentation of his No. 5: "You gotta be kidding!"

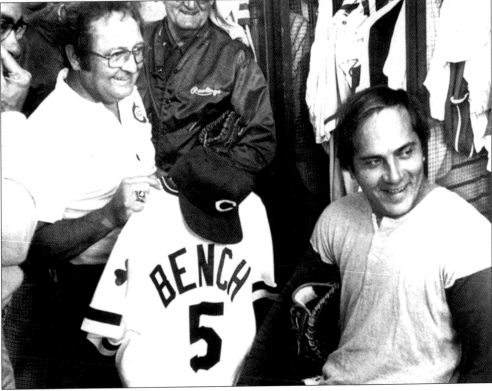

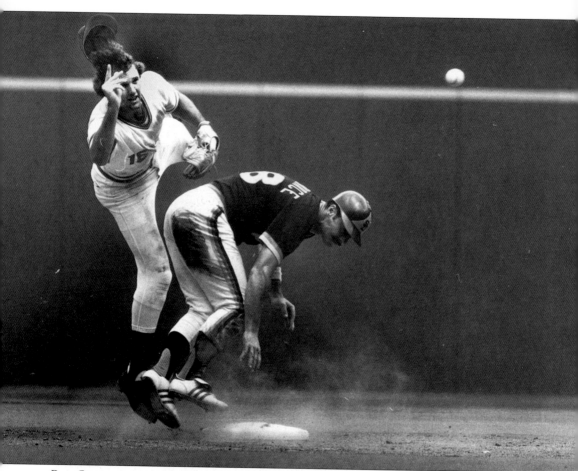

Ron Oester was a native Cincinnatian who attended Withrow High School. In 1978, he made it to the big leagues with the Reds, and for the next thirteen years, he was one of the smoothest-fielding second basemen in the National League.

Another hometown baseball product was outfielder Dave Parker, who attended Coulter Tech. Parker was an outstanding player for the Pittsburgh Pirates, and played four seasons for the Reds from 1984 to 1987. In these two photos of him, shot in the final days of Jack Klumpe's long career, Parker is seen in spring training, racing for third after singling and the outfielder bobbled the ball. The game was played under college rules with the University of South Florida, and Parker was the designated hitter. In the bottom photo, Parker has a laugh at a close pitch that put him on his keester. In 1986, the Reds had the distinction of having six native Cincinnatians play in the same game, though not all at once: Parker, Oester, Buddy Bell, Chris Welsh, Barry Larkin, and, of course, Pete Rose.

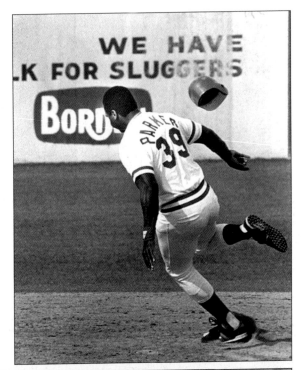

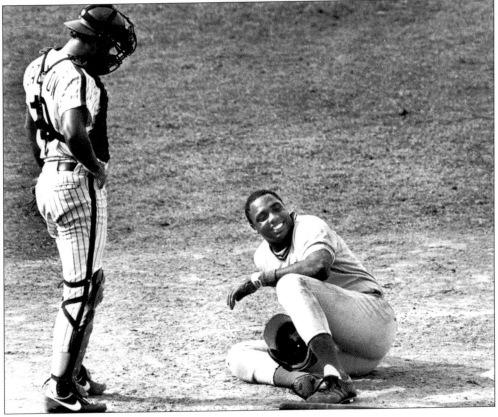

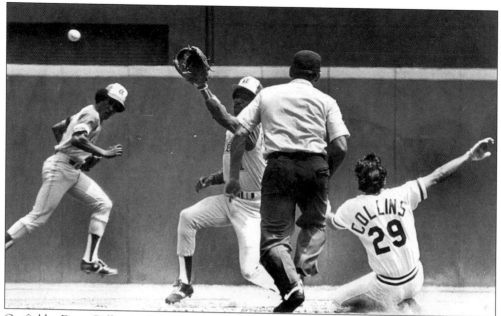

Outfielder Dave Collins is shown stealing second base in a game against the Atlanta Braves n 1979. Collins batted .318 that year.

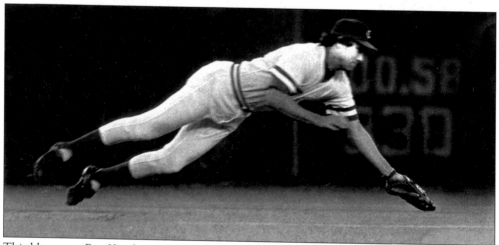

Third baseman Ray Knight joined the Reds in 1974. A solid defensive player, he got the third sacker's job full-time in 1979. Knight served as the Reds manager in 1996 and 1997.

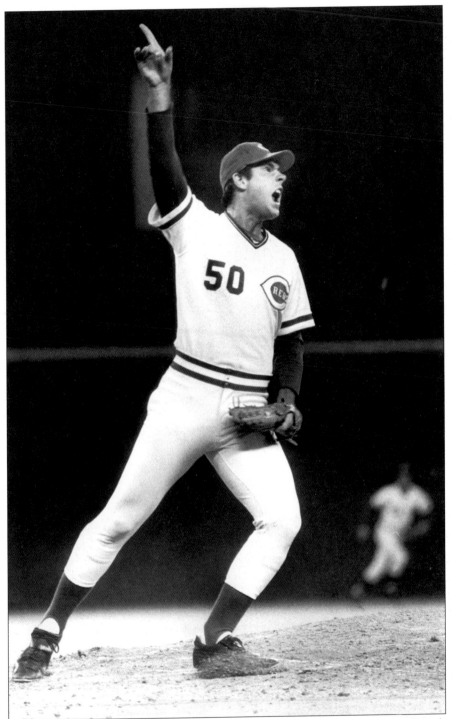

One of the more colorful players to take the mound for the Reds, Brad "The Animal" Leslie was known as much for his bellowing and histrionics when he pitched as much for his actual performance—he was reliever for the Reds from 1982 to 1984, posting an overall record of 0-3, with just six saves. But he certainly left an impression on the fans after they saw him in a game.

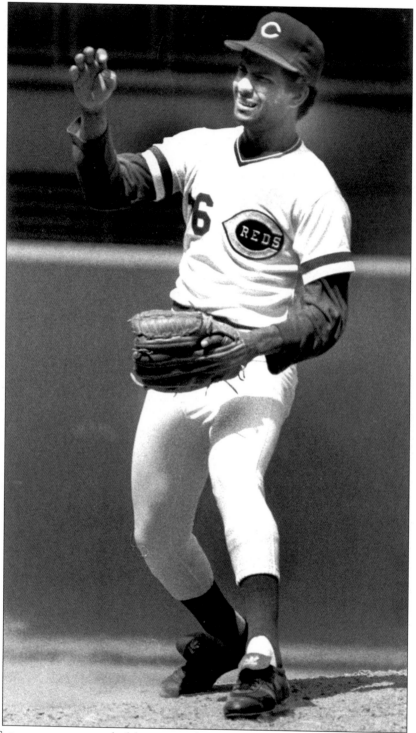

Mario Soto gave some wonderful years to the Reds, coming up to the club in 1977, and becoming an effective starting pitcher in 1980. In 1982, he won 14 games, and struck out 274 batters, besting Jim Maloney's old mark of 265.

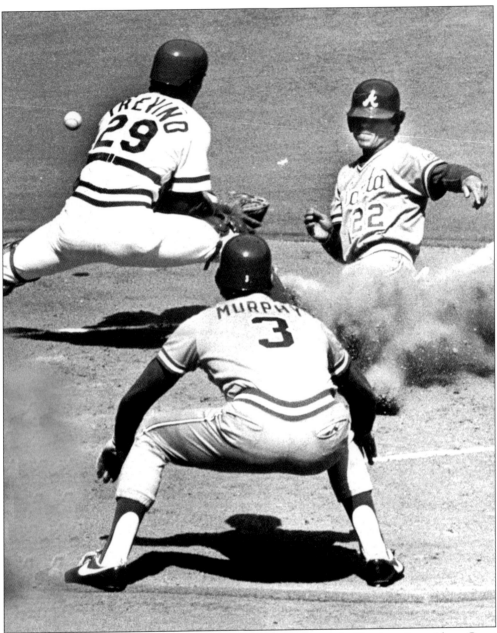

The Reds have a long history of Latino players, beginning with Cincinnati president Garry Herrmann signing two Cubans, Rafael Almeida and Armando Marsans, in 1911. Adolfo Luque, another Cuban player, was a very good pitcher for the club in the early 1920s. And, in the 1950s, the Reds had a number of outstanding players from Latin America. By the 1980s, when the demographics of the United States began shifting, and the Latino population became larger, Major League baseball clubs were also stepping up development efforts in Latin American countries. The result was the beginning of a stream of talent in the '80s and '90s that has become a river in the new century. Catcher Alex Trevino was just one of the new generation of exciting players. Beginning his career with the Mets in 1978, Trevino came to Cincinnati in 1982, playing until 1984, and again in 1990.

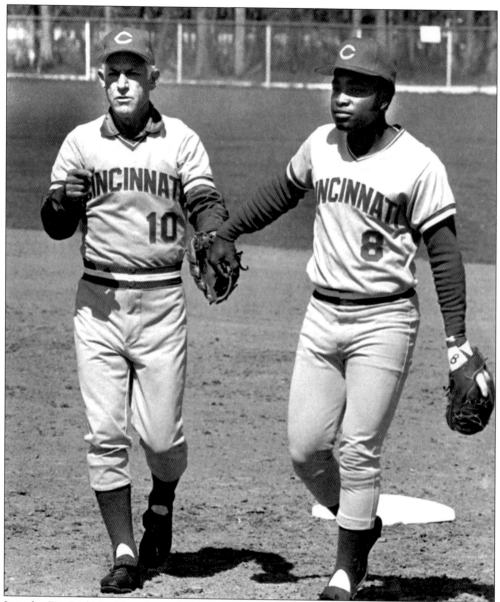

It is the Big Red Machine that will be forever part of the heritage of baseball history, and part of the identifying culture of Cincinnati. The photos on the next few pages are graphic memories of the men who made such a wonderful impact on sport. Pictured here are Sparky Anderson and Joe Morgan.

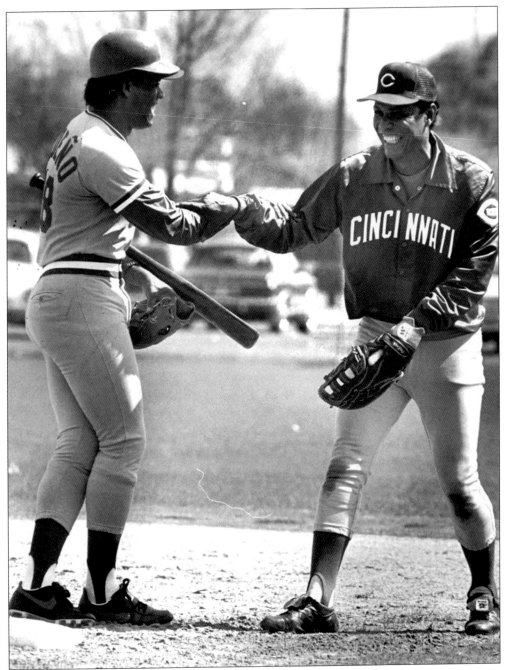

Cesar Cedeno having fun with legend Tony Perez.

Pete Rose.

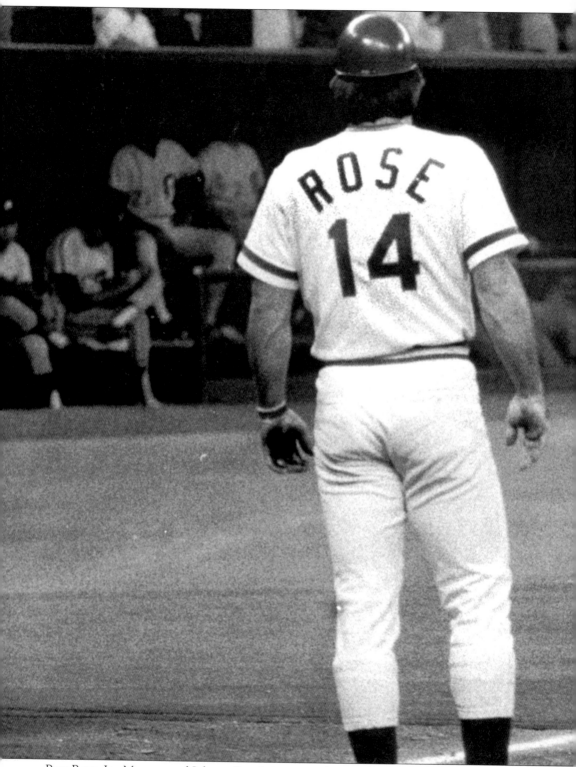

Pete Rose, Joe Morgan, and Johnny Bench in a typical scene from the 1970s.

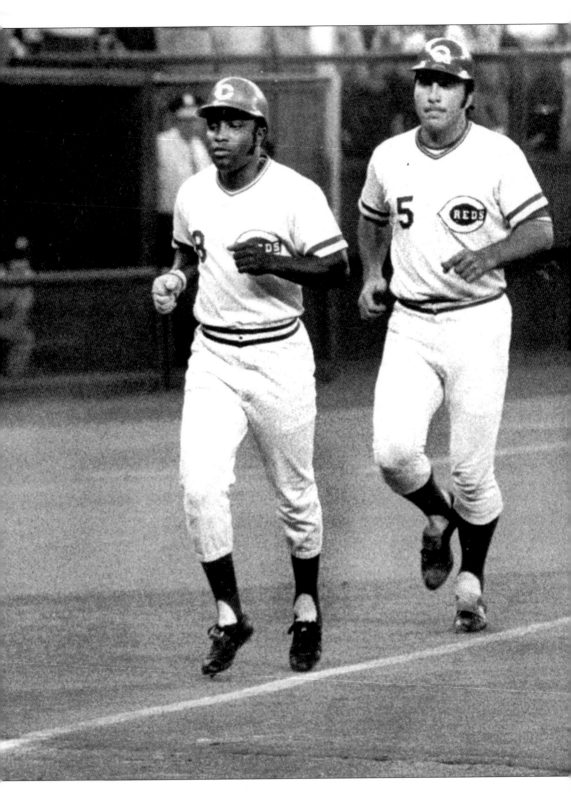

Johnny Bench.

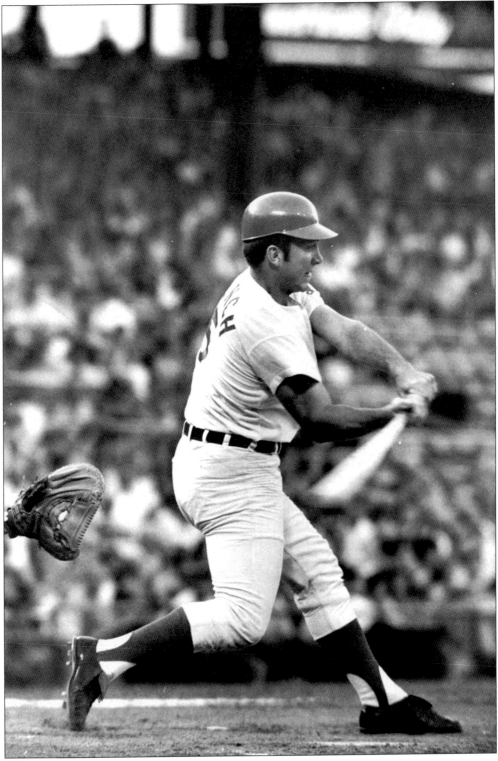

Johnny Bench.

Joe Morgan.

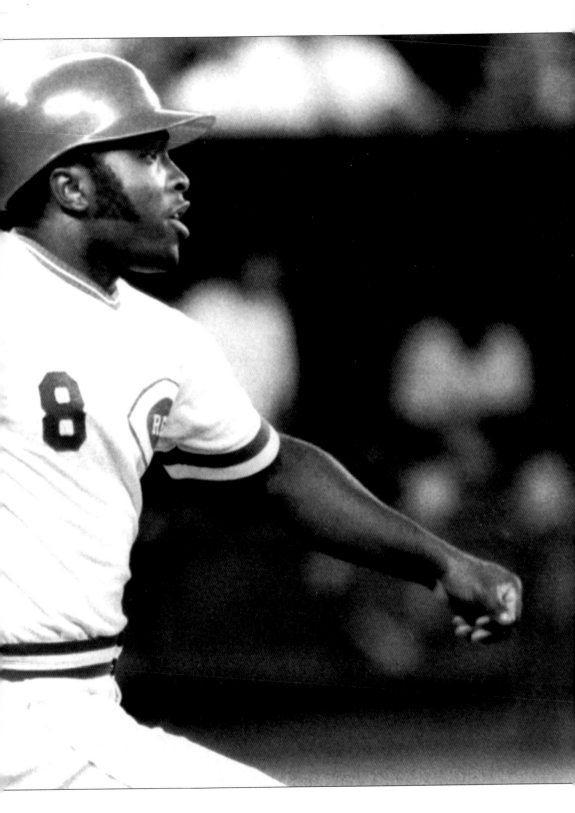

Tony Perez and Pete Rose.

There are other legends to whom another type of honor is paid: the traditional roast. In 1979, the Ol' Lefthander, Cincinnati favorite Joe Nuxhall was the subject of a roast at which the beloved pitcher and broadcaster was the subject of jests and affection. Nuxhall began broadcasting for the Reds in 1967 after he retired from the playing field (though for many years

he still threw batting practice), and it is hard to imagine a Reds game over the radio without his insight and honesty. Nuxhall is shown having some laughs at his own expense with the toastmaster, Reds television broadcaster Bill Brown, and Sparky Anderson.

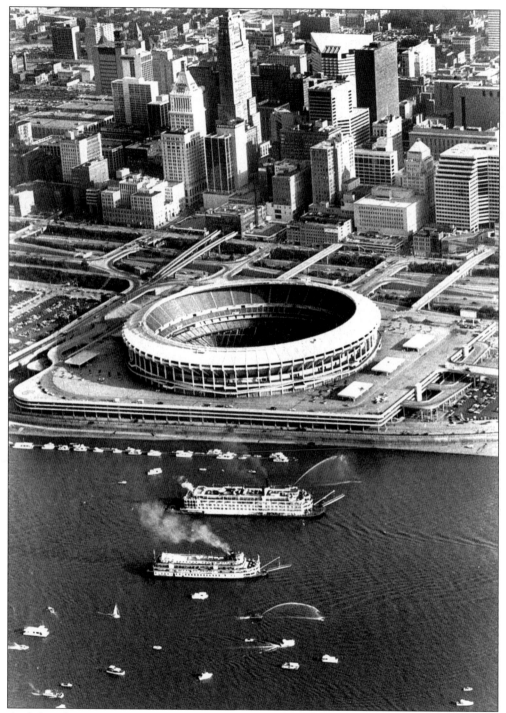

And though it was renamed Cinergy Field on September 9, 1996, for the Reds fans of the '70s, '80s, and '90s, it will always be Riverfront Stadium because it was the "Riverfront" where the Reds have had their greatest triumphs.

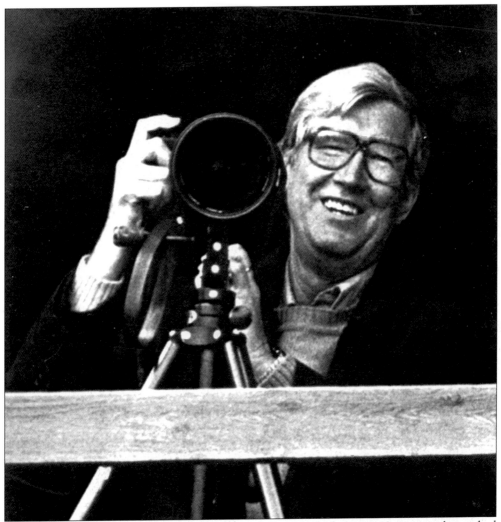
Jack Klumpe's career in photography enlivened Cincinnati for over 40 years and enriched decades of baseball fans.

Further Reading on the Cincinnati Reds

Given their long history, there are dozens of books on the Cincinnati Reds. The following titles are among the most accessible, accurate, and entertaining:

Cincinnati Reds, Inc. *Cincinnati Reds 2003 Media Guide*. Cincinnati, OH: Cincinnati Reds, 2003.

Ellard, Harry. *Base Ball in Cincinnati*. Cincinnati, OH: Johnson & Hardin, 1907; reprinted by The Ohio Bookstore, Cincinnati, 1987 and by McFarland Publishing, Jefferson, North Carolina, 2004.

Honig, Donald. *The Cincinnati Reds: An Illustrated History*. New York: Simon & Schuster, 1992.

Rhodes, Greg and John Erardi. *Cincinnati's Crosley Field: The Illustrated History of a Classic Ballpark*. Cincinnati, OH: Road West Publishing, 1995.

Rhodes, Greg and John Erardi. *Big Red Dynasty: How Bob Howsam and Sparky Anderson Built the Big Red Machine*. Cincinnati, OH: Road West Publishing, 1997.

Rhodes, Greg and John Snyder. *Redleg Journal: Year by Year and Day by Day with the Cincinnati Reds Since 1866*. Cincinnati, OH: Road West Publishing, 2000.

Shannon, Mike. *Riverfront Stadium: Home of the Big Red Machine*. Chicago, IL: Arcadia, 2003.

Walker, Robert. *Cincinnati and the Big Red Machine*. Bloomington, IN: Indiana University Press, 1988.

Wheeler, Lonnie and John Baskin. *The Cincinnati Game*. Wilmington, OH: Orange Frazer Press, 1988.